99 Digital Photo ART Ideas

angelapatchellbooks

Published by

Angela Patchell Books Ltd

www.angelapatchellbooks.com

Registered address

36 Victoria Road, Dartmouth

Devon, TQ6 9SB, UK

Contact sales and editorial

sales@angelapatchellbooks.com

angie@angelapatchellbooks.com

ISBN : 978-1-906245-11-5

Book design by Toby Matthews, toby.matthews@ntlworld.com

Book concept by Angela Patchell

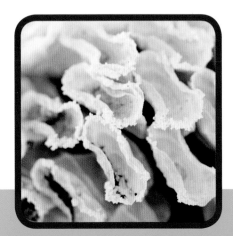
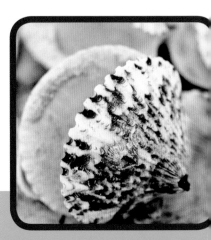

Annabel Williams

99 Digital Photo ART Ideas

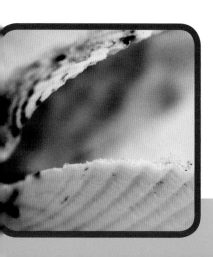
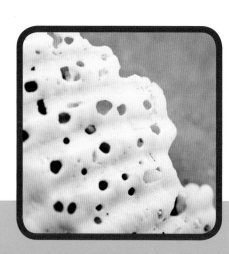
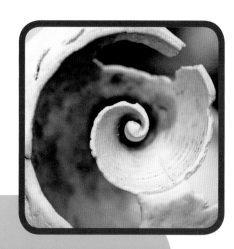

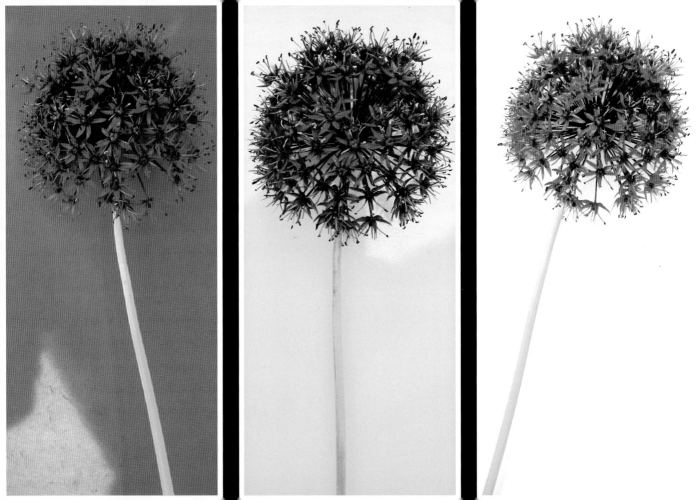

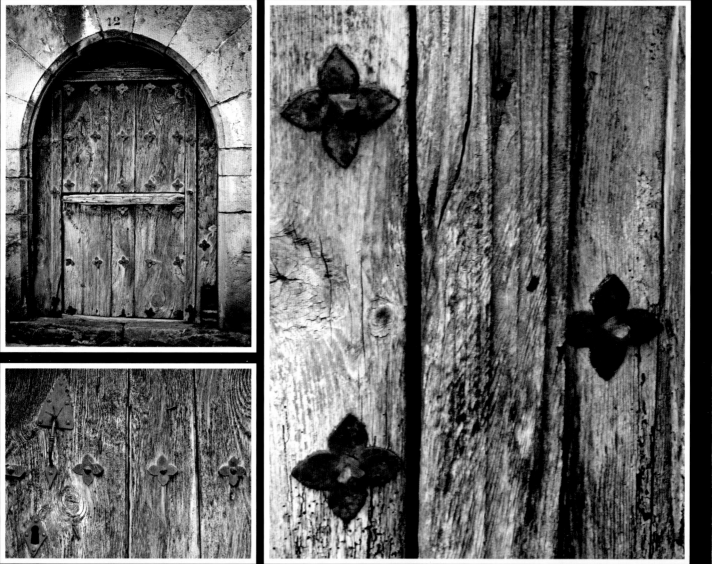

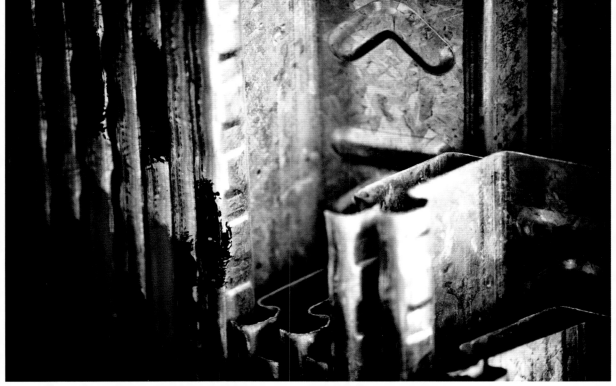

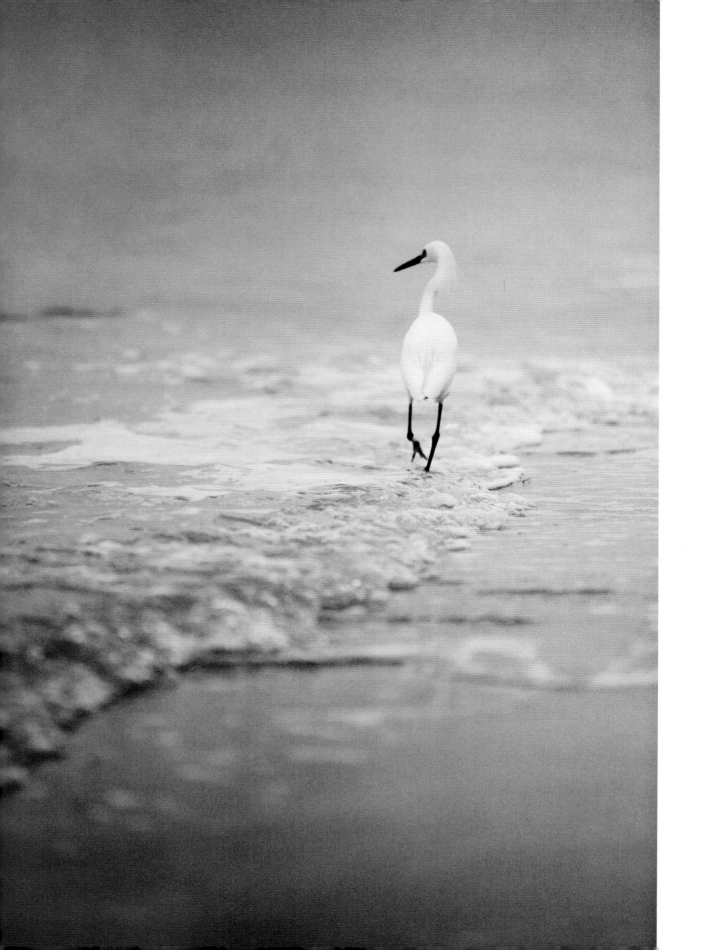

Contents

Shooting Art For Your Walls

How often do you see something you want to photograph? If you are a creative person, my guess is that you will want to photograph something every day!

Every day I see images in front of me, just waiting to be captured. I love the colours, shapes and textures of beautiful things; but I also love to create pictures from things that are not always seen as beautiful; such as peeling paint; old tin crates, metal doors and even dustbins!

I have written this book to show you how you can create exciting pieces of art from the most mundane, everyday objects as well as the more beautiful natural things that surround us; and just as importantly, how to get them from your camera to your walls!

Perhaps you are already an artist or a sculptor. Perhaps you would just love to do something with your creativity. Perhaps you like taking photographs, but don't have the confidence to exhibit your work. Photography is a great way of creating art, either from scratch or from being inspired by something you have already created.

Are you worried about technical things like cameras? Well, I'll let you into a secret … photography is actually really, really easy.

Picking up your camera is as easy as picking up a paint brush, it's what you do with it that makes the difference.

Don't let your fear of cameras spoil your creativity. Anyone can learn to use a camera, it's being inspired and knowing what you want to photograph that is important.

Think about photography differently!

Forget about the technical side and concentrate more on what's around you. The camera is actually the last thing you need to take a photo – honestly! The moment you decide to press the shutter is

crucial, but it's everything else you do before you press it that makes it a great photo.

Take time out to get creative!

Follow the simple exercises in this book, and start to see things differently.

Set up your camera so it becomes second nature. You should be able to pick it up, switch it on and take a picture immediately. No more worrying about how to set it up! In a few more pages you'll know how, and then you will always be able to take a great picture just by switching on your camera and pressing the shutter.

Once you've taken the pictures, you'll need to know what to do with them. Don't leave your photographs inside your camera, follow a few simple steps and set up a system so that you can take pictures freely in the knowledge that you can create fantastic pieces of art from them later.

It's so exciting to create your own art for your walls – be inspired and get creative!

I have spent many years photographing people, and I also enjoy photographing the things that surround them too! If I am taking pictures of a child, I am also taking pictures of her shoes, or her doll, or the pebbles on the beach where she is playing. Everything and anything can be photographed.

I love experimenting and always shoot things from lots of different angles to gain as much variety as possible.

By learning from experience (both good and bad), I've gained the confidence to believe in myself and what I do. So many of us aren't using our passion and creativity due to lack of confidence in knowing what's right and what's wrong.

Well the good news is there is no right and wrong! There is only what you feel is right. So, as you read this book, keep an open mind and allow yourself to believe you can do it.

Confidence fuels creativity. It gives you the motivation to try new things, and the ability to bin anything that doesn't quite work.

Photography is something that most people enjoy, and I hope this book will help you to believe that anything is possible when you're taking a photo. There are no rules – only inspiration.

You can choose what to do with that inspiration and hopefully, with a few simple techniques, you will gain the confidence to focus on your passion and create your own style.

Experiment, open your eyes and your mind, and allow yourself to be inspired.

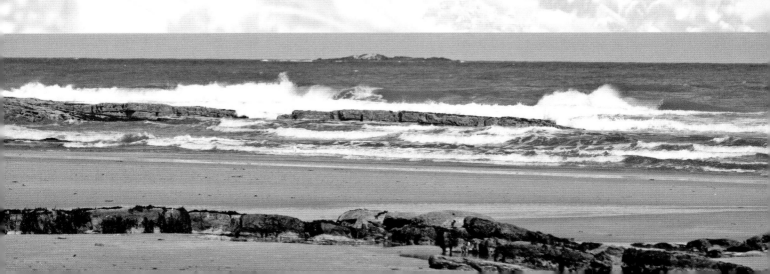

1 ALL YOU NEED TO KNOW

Learn to love your camera!

For many years photography has been a very technical subject – but fear not – all that has now changed! Digital photography has made everything so much easier. Don't worry about the technical side – you don't need to know many things in order to be able to take great pictures. If you are constantly worrying about which F stop to set your camera on, and which dial does what, you will lose all your confidence and it will make it so much harder!

What kind of camera do I need?

You need the camera you feel most comfortable with. If you want to keep a camera handy at all times to capture things you see in everyday life, then you may like to use a simple compact digital camera. If you want to improve your photography and create more interesting pictures, then you may like to use a Digital SLR camera.

A Compact Camera

1 It is easier to carry around with you.

2 It's quick and easy to use. You are more likely to catch every moment because you are not carrying lots of equipment with you.

3 BUT....you need to think about shooting smaller images in sets, because you may not be able to create huge pictures due to the smaller file sizes.

ANNABEL'S TIPS

In my opinion, the most important aspects of Art photography are:

1 *Inspiration*

2 *An open mind*

3 *Light*

4 *Equipment*

… in that order!

A Digital SLR Camera

1. You can be more creative, as you can change the lenses for different effects and you can have more control over the way you shoot.

2. You have a much bigger file size for storing more information which means you can create much larger images for your walls.

3. BUT....they are much heavier to carry around, so you will need to think about going on a shoot, rather than just grab your compact.

Equipment used in this book

Digital compact – Canon Power shot A710 IS
DSLR (Digital Single Lens Reflex) – Canon 1Ds 11
Canon 100mm F/2 macro lens
Canon 70-200mm F/2.8 zoom lens
Lowepro rolling compu trekker bag and belt pack

ANNABEL'S TIPS

Be Ready!

Make sure your camera is set up so all you have to do is switch it on and grab that shot!

How do I use my camera?

» It's simple – think of your camera like your washing machine! How many settings do you use on your washing machine? I bet it's two at the most.

» Think of your camera in the same way – set it up easily and trust it to do it's job (see next page).

ANNABEL'S TIPS

Lenses

If you are using a DSLR get yourself a zoom lens (70-200mm) for versatility and a macro lens for close ups.

Photographing art is fun! But how often do you visualise something and are then disappointed with the results because you didn't understand your camera properly? You need to set your camera up simply and easily so you never have to think about it again! It's rather like your car; you can drive a car without understanding exactly how it works. You just learn to use the bits you need and let the rest take care of itself.

TIP – **Start with simple techniques and add as many new techniques as you like later!**

» The great news is you don't **NEED** to understand everything about apertures and shutter speeds!

Using wide apertures can create a more artistic feel to a picture, because you can throw the background out of focus; making the scene less "realistic" and keeping in focus the parts you want to emphasise.

» Do you remember how difficult it seemed when you were learning to drive? Once you've learnt, you don't even think about the car – just about where you're going – and it should be the same with your camera.

Aperture

All you need to know is that if your camera is set around F4 or 5.6 the background of your images will be more out of focus, than if it is set around F11 or 16.

So if you want everything in focus, use the higher numbers. If you want more of the background out of focus, use the lower numbers. **THINK** – less in focus – lower the number. But don't worry, your camera is going to do all this for you!

Shutter Speed

The shutter speeds represent how long your shutter is open for (ie. 1/125 of a second). The longer your shutter is open for (15th/30th of a second) the more chance you have of blurring the image. The quicker your shutter is open for (125th-8000th of a second) the less chance you have of blurring the image.

EXPOSURE
Apertures

16 11 8 5.6 4 2.8

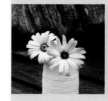 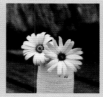 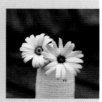

At F16 the tree bark in the background is quite clear. At F5.6 it is more out of focus, placing more emphasis on the subject, and at F2.8 this is even more apparent. Note how the words on the vase and the rear flower are now going out of focus too.

EXPOSURE
Shutter Speeds

15 30 60 125 250 500 1000 2000 4000 8000

Slower | **Faster**
Movement More Blurred | **Less Blurred**

The slower the shutter speed the more blurred the image will be if your subject is moving, but this can be very effective in some situations, such as this fairground ride, where we want to show the movement.

The faster the shutter speed the less blurred the image will be, but sometimes when the light is poor, it is not possible to get a fast shutter speed, and you need to make sure your subject is still, and you hold your camera steady in low light conditions.

COMPACT CAMERAS

A rough guide to using their settings

Compact cameras usually have preset modes to help you get the best results.

Face 🏃
*This will set the camera on a wider aperture (F3.5-5.6) when shooting fairly close subjects so the background is more **OUT OF focus**. Use for most things that are close.*

Mountains 🏔
*This will set the camera on a smaller aperture (F11-22) when shooting landscapes, so the background is more **IN focus**. Use when you want most of the picture in focus.*

Macro 🌷
*This will set the camera so you can focus on the minute detail of you subject and the background will also be **OUT OF focus**. Use for very close up objects and detail.*

Auto 📷
*This will set everything to an average, but the background is usually **IN focus**. Use for general snapshots.*

How to Set Up Your DSLR Camera

Setting up your camera to make it easy to take great photos needn't be complicated. Follow these simple instructions and you will be well on your way to taking that fabulous picture.

TIP – **Before starting you may need to refer to your "Quick setup guide" as each camera may vary slightly.**

- **Set your camera mode to Av**
- **Set the aperture to 5.6**
- **Set the ISO on 400**
- **Set the camera to "one shot"**

Exposure

Now find the exposure setting which has 3 different settings like this:

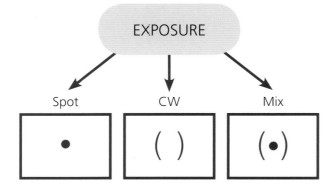

Set your camera to (•)

Focusing

Set your focusing to just ONE RED SQUARE in the middle of the viewfinder.

FOCUSING

Set camera with just one red square in the middle

How to Create the Correct Exposure

Once you have set your camera as shown practise the following:

1 Compose your picture, then move your camera so the red square is over the subject you want to focus on.

2 Hold down your shutter button half way (this will freeze both the exposure and the focus).

3 With your finger still holding the shutter half down, move your camera to the original composition.

The camera will keep the exposure and focus and this will ensure that the subject is correctly exposed, and it doesn't matter if the rest of the picture is washed out – it will only make it look more interesting!

PRACTISE!
PRACTISE!
PRACTISE!

WARNING!

While shooting, keep your eye on the number which flashes up in your screen. This is the shutter speed, which the camera is setting itself. Occasionally in low light conditions it will be very slow and your picture may blur. Provided it is 125 or higher (250/500/1000 etc.) it should be fine, but beware if it shows 60 or less (30, 15, 8, 4 etc.) because you need to hold your camera really steady to avoid blur.

TIP – If you see these low shutter speeds, adjust your ISO to 800, which will increase the speed slightly.

This is a picture of a green wooden chair in front of some red metal doors. To achieve shot no. 3:

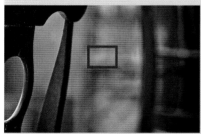

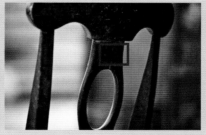

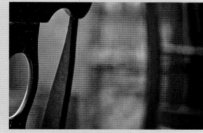

1. Compose your image with the chair on the left hand side of the picture. You will notice that the red focusing square is in the centre of the picture, and if you took the picture now, the subject would not be correctly exposed or in focus, so …

2. Move your camera so that the red square is now over the chair. Press the shutter half way down, and this will lock the focus and exposure on the subject.

3. Whilst keeping your finger pressed down, move your camera back to your original composition and press the shutter.

If you let go of the shutter, the camera will refocus on the central point of the shot and this will be the result.

Setting Up Your Camera

Is File Size Important?

It depends on what you want to do with your final image.

All digital cameras have a variety of file sizes – this is basically the amount of information they can store on one file – or image. The more information in the image the more you can enlarge the picture afterwards.

RAW (DSLR only)	LARGE (L)	MEDIUM (M)	SMALL (S)
More information stored			**Less information stored**

If you shoot on RAW you will have much more opportunity afterwards for producing a very large detailed picture. **HOWEVER,** the file sizes are so big you will need lots of storage space on your hard drive, and it takes much longer to download and work on the images.

The good news is that you don't have to shoot on RAW, a LARGE jpeg is quite sufficient for most people to work on; it requires less storage space, and you will get a lot more images on your flashcard.

» Technical people will often disagree with me on this, but like everything I do, I want to use the **EASIEST**, least time consuming ways in order to get the pictures I like. Provided you stick to good light, and good exposure a jpeg will be absolutely fine, and it means that instead of sitting on your computer all day, you'll have time to get outside and **GET INSPIRED!**

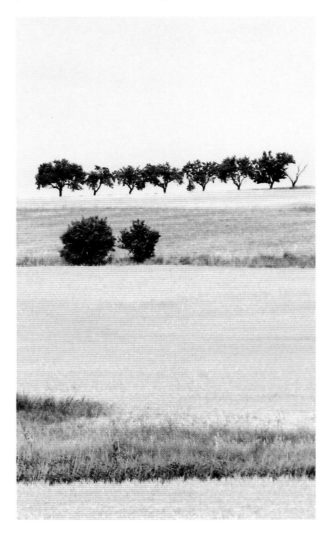

NOTE – If you are using a compact camera the LARGE jpeg will be considerably smaller than the LARGE jpeg on a DSLR camera – in other words if you use a DSLR you will usually be able to enlarge your picture to a good size for the wall – say up to at least 1m or more. The largest sizes on a compact camera will only produce an image of about 45cm. Anything larger and the pixels in the image will start to show.

However, this is not a problem if the pixels actually enhance the image, or you shoot in sets!

TIP – **Take several different angles of your subject so you have more than one image. Then you can place 4 × 45cm pictures in a large space creating a piece of art which is around 1m.**

ANNABEL'S TIPS

No More Space?

If you are running out of space on your flashcard, changing the file size from LARGE to MEDIUM or SMALL will give you more images – but don't forget – you will not be able to make big pictures out of a small file, so only do this if you know you are going to be reproducing the picture at a small size. Only use this as a last resort. Carrying a spare flashcard is a much better idea!

» Make sure you buy a flashcard of at least 2GB, and buy a spare! So you have plenty of space for all the beautiful images you will be taking!

» So if you are shooting art for fun, and for your own walls … set your camera to Large and this will produce high quality jpegs for you.

Is File Size Important?

To get great pictures it is important to use great light! This does not mean it has to be bright sunshine – great light is basically the best light for the subject! With people, I like to shoot them in the shade because this creates a very flattering light for their faces, which is the most important thing if they are to like themselves in a picture.

ANNABEL'S TIPS

No Flash

Don't waste time with flash – it nearly always looks artificial and I find pictures look more natural if you use natural light.

Bright Light

Direct sunlight is not good for faces as it causes the subject to squint, and look shadowy. However, with landscapes and abstract art you can use any kind of light to different effect because you are not worrying about whether the tree likes himself or not! You are dealing with shape, colour and texture, rather than its self image!

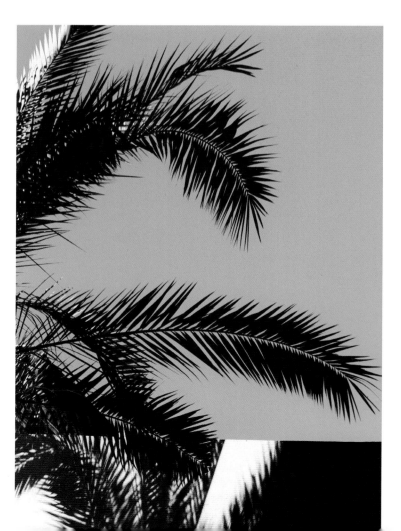

Soft Light

Soft light is usually found on overcast days, when there are clouds around which filter out the sun. This can create a beautiful effect on faces, and create a soft even light for other subjects.

Look on the bright side! Shoot it how it is, and make the most of it.

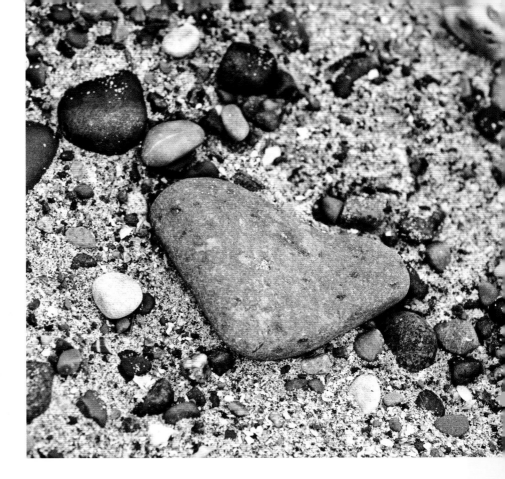

The weather is what the weather is!

I don't wait for the weather to be 'perfect' – I just use whatever light is available to create pictures if I am feeling in the mood that day! If it's bright and sunny, then my pictures will have lots of contrast and brightness in them. If it's cloudy, they will be soft and neutral pictures; if it's raining I may shoot water, or the beautiful detail on a pebble you only get when it's wet.

Cropping

I always try to crop everything in camera as much as I can because it produces better pictures if you think about everything first. You will also lose quality in the image by cropping a section out of it, so bear in mind that your image may not enlarge as well if you crop it later.

However, sometimes it is just not possible to get in close enough to your subject, or take a square picture or panoramic, and therefore cropping later can be very helpful if you want a specific look.

OPTION 1 - ANY SIZE

To crop to any unspecified size just use the crop tool from the tool bar on the left.

Click on the 'crop' icon, and then click on the image where you want to start your crop. Drag the cursor to the desired crop.

Click again on the 'crop' icon and then on 'save'.

OPTION 2 - SPECIFIC SIZE

If you want to crop your picture so it fits a specific frame size – say 10 × 8 ins, then you can type in the size in the relevant boxes at the top and when you crop the image (as above) it will keep the proportions of that size.

OPTION 3 - SQUARE

To keep your image square as you crop it, hold down the 'shift' key on the keyboard at the same time, and the crop will remain perfectly square. If you want a specific size of square use option 2 above at the same time.

REMEMBER – the more you crop your image, the less information you will be keeping and the less you can enlarge the final picture. Try and zoom in to the crop you want when shooting, if you can.

OPTION 4 - PANORAMA

Use option 1 or 2 again to create the panoramic shape you want.

Removing Dust and Blemishes

Occasionally there will be something you need to remove from a picture, like a dust spot or other mark. Try and keep the sensor clean on your camera to avoid dust spots; use a simple blower brush and follow the camera instructions for cleaning the sensor. If changing lenses, try to do this quickly and in a dust-free zone!

If there is something you need to remove you can do it easily with the **'PATCH TOOL'**.

STEP 1

Go to the 'healing brush' tool on the tool bar on the left hand side. Click on the little arrow in the bottom right corner and you will find the 'patch' tool beneath. If you click on it, it will become the icon on the tool bar (second image).

STEP 2

Highlight the patch tool. Then draw a circle round the mark you want to remove, with your cursor. Drag the circled area over an area of the picture which is the SAME colour, and let go. This area will then appear over your mark, and the mark will have disappeared (see below).

This swimming pool had little chips of paint missing from the tiles, but I have removed them all with the help of the patch tool. Much easier than draining the swimming pool and repainting it!

After

As you will see throughout this book, 'Curves' is my favourite Photoshop tool. I use it on every image I take, either in a very subtle way, to simply brighten it up, or dramatically, to completely alter the look of the picture, depending on the effect I want to achieve.

Subtle Curves

STEP 1

Open up your image in Photoshop, and find 'curves' in the 'image' menu of the tool bar.

STEP 2

Brighten up the image by adjusting the curves as shown above. For a subtle effect, you will only need to make small adjustments like this.

Dramatic Curves

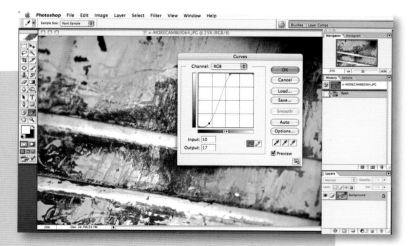

STEP 1

This image will need much more adjustment to make it look attractive as it is part of a dustbin (see chapter 4) and therefore not a conventionally beautiful shot to start with!

STEP 2

Brighten up the image by adjusting the curves as shown above. For a dramatic effect like this you will need to adjust the curves much further, as shown above. This technique is useful for 'pop art' style pictures and it's a case of experimenting until you like the final look.

Black and White

There are many techniques for converting an image to black & white, and it's down to your personal preference at the end of the day. Gradient map is my favourite simply because I like the result better than other methods I have seen.

ANNABEL'S TIPS

What To Do First?

Alter your images in curves and remove blemishes etc. first, before converting to black and white to achieve a better final image.

STEP 1

Open up your image in Photoshop and enhance in curves to achieve the level of brightness you want.

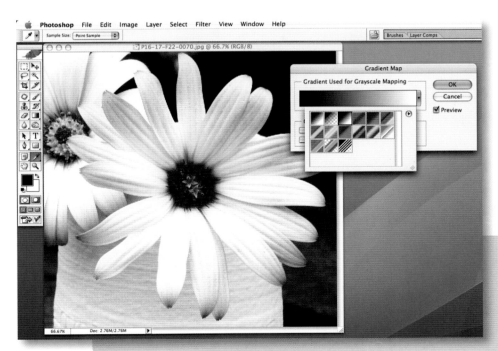

STEP 2

Find 'gradient map' from the 'image' menu on the tool bar. Click on the little arrow to the right, and then on the 3rd box.

Black and White

2 INSPIRATION

Start by looking around your house. Where would you like to put your art? In the sitting room, kitchen or bedroom? Look at the colour scheme in your room – is it brightly coloured? Does it have an accent of colour? Or does it have neutral and natural tones?

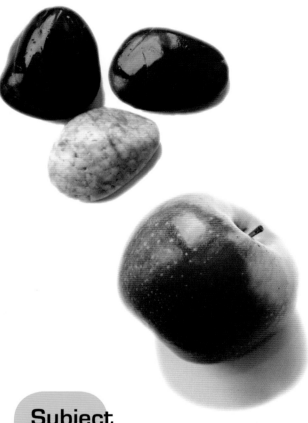

Shape

Shape is also really important. Look at the wall on which you want to display the art. Would it suit a large rectangular picture? Should it be vertical or horizontal?

Should it be square?

Should it be just one large picture or would it look better if it was a set of 3 pictures in a line, or a set of 4 pictures in a square?

You don't have to make all these decisions now, but it will help you to focus later if you have thought about it and created some rough ideas in your mind.

Subject
THINK!
What appeals to you?
What are you drawr to?
Light?
Water?
Nature?
Fruit?
Pebbles?
Shells?

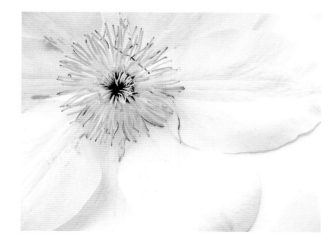

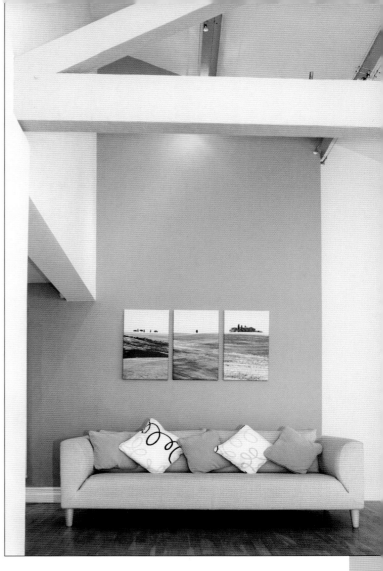

ANNABEL'S TIPS
Colour Schemes

Different colour schemes require different art.

Looking at the décor in your room should inspire you to create something which would complement the scheme.

Colour

Do you want pictures which include colours in your room, or contrast with those colours? For example, a room with bright blue colours would look good with artwork of a similar colour, such as seascapes or skies. But it could look equally good with a complete contrast, such as orange or yellow.

Neutral or natural tones, would look good with artwork which is soft and blending – perhaps the sand on the seashore, or elements of natural texture such as grass, pebbles or shells. Should the pictures be colour or black & white? Again look at your rooms for inspiration. In Chapter 3 there are lots of ideas which will work for all sorts of colour schemes.

» Try to think of an idea first and then experiment and have fun

Liberate yourself and your camera!

Once you have set your camera up, do this excercise before you do anything else - it will make all the difference to your inspiration and creativity.

1 Try the "COLOUR/SHAPE/TEXTURE" exercise, which is in 3 parts, and each part should take about 10-15 minutes (or longer if you get really inspired!)

2 Open your mind and allow yourself to think differently. Take your camera outside to somewhere not naturally pretty – like a car park, or a street – somewhere urban, or industrial rather than a beach or a park at this stage.

Limit yourself to only 10 shots!

Trust me, this will really help you to be inspired and creative!

ANNABEL'S DIGITAL TIP

Curves

Increase the colour and contrast later by using curves (see page 26).

Start looking at the detail! Look at the colours that are around you, and create your art from them. Here the blue paint on these wooden pallets is stunning.

This may just look like an old rusty oil drum at first sight – but zoom in closer and look at the beautiful colour of the yellow paint against the brown rust.

Part 1: Colour

First of all wander around the area and look for things which say "COLOUR" to you.

Take 10 photos of "colour" – you can choose anything you want – just make sure when you press the shutter it inspires you in some way. (no- you can't delete any – you can only press the shutter 10 times!)

TIP – **You will be amazed at how limiting yourself to 10 shots will transform your photography because you really have to THINK about each shot.**

TIP – **It may take you a couple of minutes to get into this exercise, but keep going – it will make so much difference to how the rest of this book will work for you.**

TIP – **Try and zoom in close to the objects, and get the background out of focus – DSLR users shoot on 5.6 or 4 to achieve this, compact cameras use the macro setting (❀) – these adjust the camera automatically to get your backgrounds more out of focus when you shoot up close.**

ANNABEL'S TIPS
Colour

Look for single colours, but also colours that work together or contrast. You could use bright colours or muted colours, soft or harsh colours.

Getting Started with Colour, Shape and Texture

Part 2: Shape

REPEAT the exercise looking for things which say "SHAPE" to you – again you may only take 10 shots.

TIP – **Try tilting your camera at an angle slightly – it will make your picture more interesting and dynamic.**

TIP – **Try looking sideways at things, rather than straight on – this helps you to focus on an object and allow the background to go away from you, creating more interesting shapes.**

The shape of the metal meshing is quite dynamic when parts of it are out of focus. The squares against the lines of the wood behind create interest and contrast.

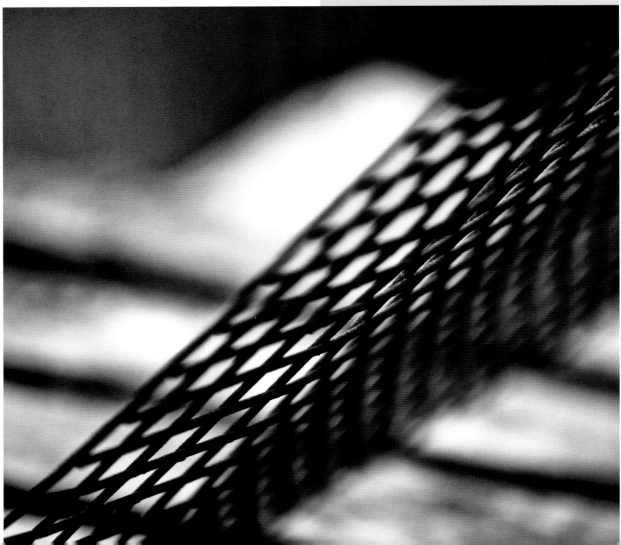

4

Look at the shapes and patterns that are formed by the stacked metal. Use curves later to enhance the shape and colour dramatically. Metal always looks amazing when you use curves to brighten up the image – it takes on a totally different appearance.

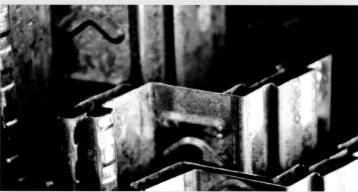

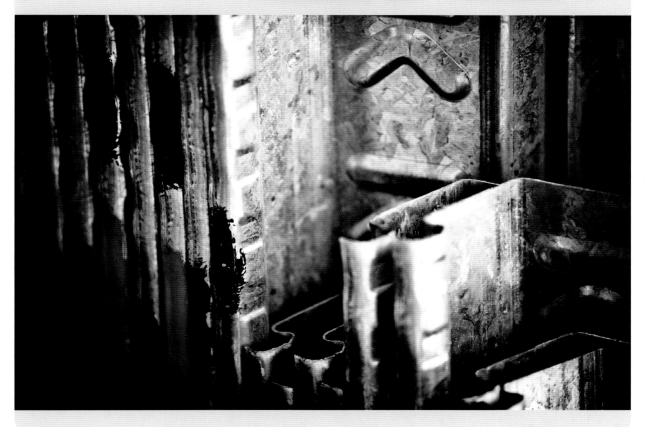

Looking at Shape

Part 3: Texture

Repeat the exercise again! Look for things which say 'texture' to you – and again, you may only take 10 shots.

Old dry wood creates texture that you can almost feel in the picture.

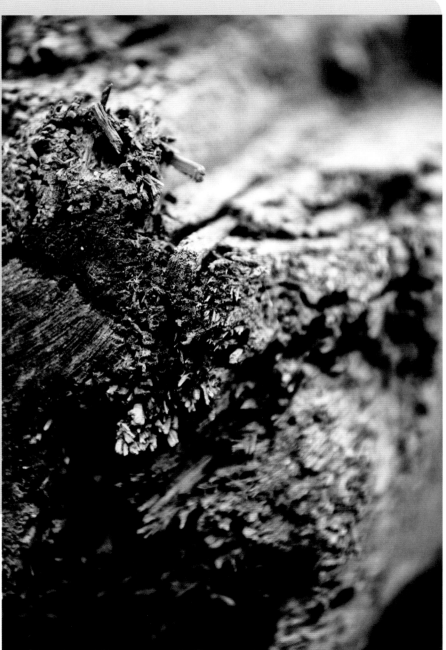

» Get out there and have fun!

TEXTURE

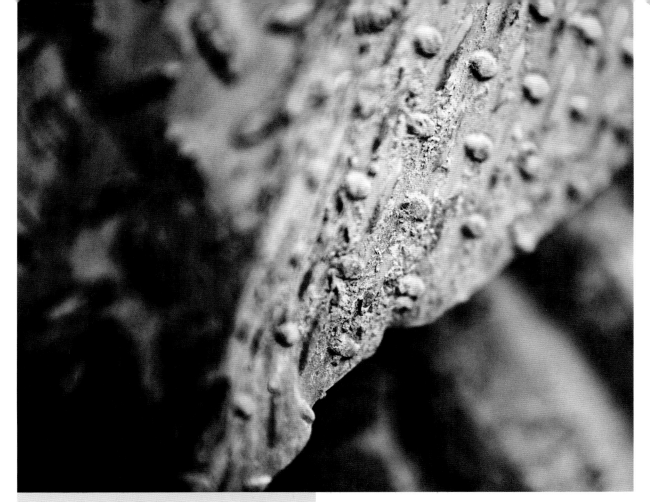

6 The most amazing things can look good on your wall – even the texture from a section of a yellow dumper truck!

Finally ...

When you get back, download your images and choose your favourite one – tweak the curves in Photoshop (see page 26) to brighten up the image, print it out, mount it, sign it and frame it!

I've done this exercise many times with photographers, and I find this is a real turning point for them. Being allowed to shoot only 10 images each time really helps them be more creative, and seeing the end results always gives them much more confidence!

It's a great way to get motivated and inspired to take more pictures.

>> Try photographing
peeling paint,
tree bark, jagged
plastic, metal,
wood, paper, stone,
you'll be amazed at
how creative and
inspired you will feel!

This is a section of the metal factory door, which
has been enhanced in curves again. The texture and
colour are amazing as a piece of Art.

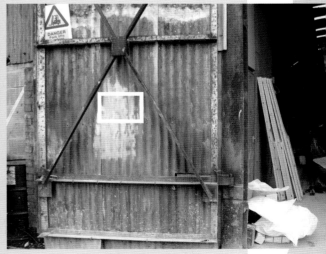

Looking at Texture

Good composition can make all the difference to a picture. Composition really means putting things together to make the whole picture work, rather than just shooting what is immediately in front of you.

How do you do this?

Some people do it naturally, while others have to work at it. But the best advice I can give you is to have the confidence to believe in what you do – if you like what you see **SHOOT IT!** If you don't like it, move it (or yourself) around until you do. If you are a creative person you will know when it looks right, because it will feel wrong until it does! This is one of the reasons I suggested you do the **COLOUR/SHAPE/TEXTURE** exercise on pages 32-39, because it really will help you to compose your pictures better.

TAKE YOUR TIME, LOOK, THINK, EXPERIMENT, DON'T BE AFRAID TO CHANGE THINGS.

ANNABEL'S TIPS

Remember – if something does not look or feel "right" to you, it probably isn't. Move on, and try something else!

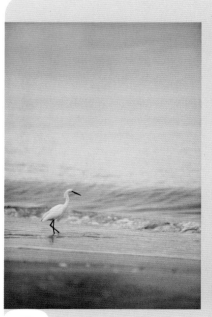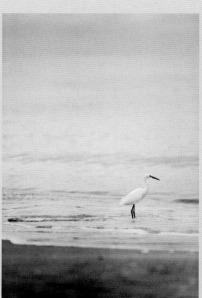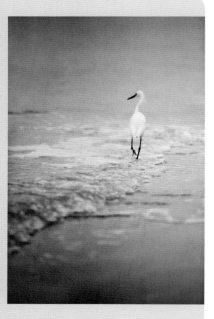

These 3 images show the bird in different places in the picture – do you prefer it on the left, the right, or at the top? I actually think they all work!

Ideas for good composition

1 Look at the shapes of what you see – how does the picture look if you include or exclude certain things?

2 Does the picture work better if the subject is at the top of the frame, bottom of the frame, in the middle, or to the side? Move your camera around and decide for yourself. If you are not sure, shoot them all and then look at the results. Sometimes things work in lots of different ways, sometimes it's obvious that it only works in one way. THERE ARE NO RULES!

3 Don't include too many objects in your picture – the simpler the better. Too much stuff and your composition will be cluttered. Focus on one object and let the background work around it.

4 Try zooming closer into your subject, and then zooming much further out – which one do you prefer? Or do both of them work in different ways?

ANNABEL'S TIPS

Try to compose your picture when you shoot it – don't rely on changing it later on your computer, as it will not be nearly as good as it will be if you think about everything first.

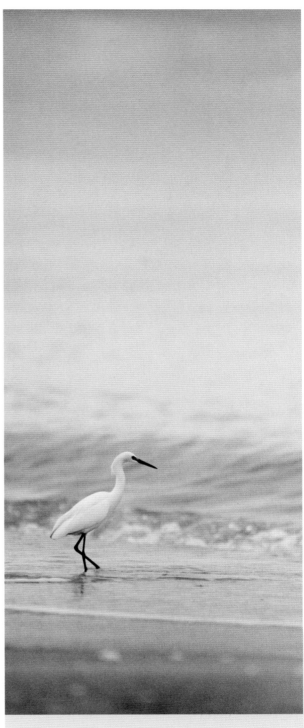

Finally I decided to crop the picture as a tall panoramic, keeping the bird on the left. That's the great thing about composition – you can choose what to do, and experimenting will help you work out what looks best.

I always try to crop everything in camera as I shoot it; this way I think much more carefully about the final image. However, sometimes I may want the shot to be square or panoramic; in which case I know I will be cropping it later on the computer, but will still think about how it will look as I shoot it.

A picture will have a much stronger composition if you crop all the distracting things out of it. Look at what is around the edges of your picture – do you need it all? Zoom in closer and see if the picture looks better.

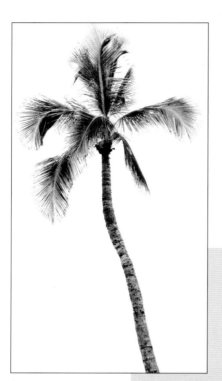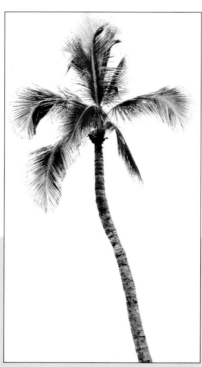

Sometimes it can be very effective to repeat a shot on a wall to create impact, as I have done here with the palm tree. By cropping the image tightly the shape of the palm tree really stands out, and by repeating the image to create a set of 3 pictures, the result is a piece of art with high impact. I have used curves here to completely wash out the sky and create something linear rather than colourful.

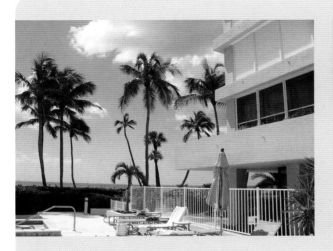

This is a typical holiday scene, beautiful palm trees against a blue sky by an apartment swimming pool. This picture however is just a 'snapshot' – by zooming in closer and getting rid of the distracting building and chairs you can create a much better shot.

Sometimes you just can't crop in to remove everything that is distracting and you may have to recrop slightly later or remove a distraction by using the patch tool (see page 25). Also on some cameras the actual image is slightly larger than the one you see through the viewfinder. On the shot above right the palm leaves on the right of the shot are distracting, and without them this shot is much stronger.

Cropping and Formats

Try not to think of only one shot – start thinking in sequences, and you will improve the way you take pictures. Thinking of just one shot can be very limiting. I often find there are many many ways of looking at the same thing – and it's much more fun to photograph something from different angles, and create shots which work together but are all slightly different. This way you can create a piece of art on the wall which is made up of several shots rather than just one.

TIP – **If you take just one shot there is often a tendency to stop there and think you've got it. If you look at something in different ways and take more than one shot, you will get more involved with the subject and get to know it better, resulting in you seeing more elements of that subject.**

12

13

Here I was inspired by the bright blue colour of the swimming pool and the reflections of glass windows in the water. There were an infinite number of pictures to be taken as the shapes changed constantly as I looked at them.

14

I selected my favourite 3 shots, cropped them into squares, played with them in curves and finally placed them as a set of 3 together.

15

» Sometimes the best picture is the first one you take, but more often than not, the pictures get better and better, particularly if you really study the scene closely.

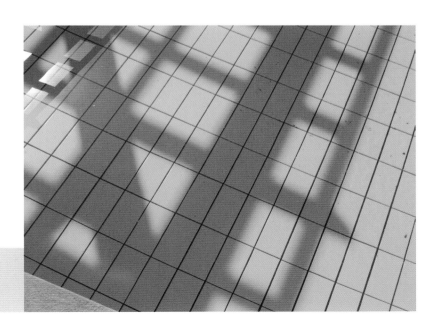

This is one of the original shots, which is transformed by using curves (see page 26).

Shooting in Sets

Lighting is a very important aspect of photography, because it makes a huge difference to the effect you can create in your photographs. Bright sunshine can be fantastic for landscapes, and also for enhancing shape and texture in a photo. But equally, soft muted light can create great atmosphere in a picture. It just depends on the effect you want to achieve.

Don't feel that you have to have sunshine to take a great picture – that's not the case at all.

In these two pictures, the sea has been photographed in the same location on two different days– one a sunny day and one a stormy wet day. Both pictures work equally well as art, because they both create totally different moods.

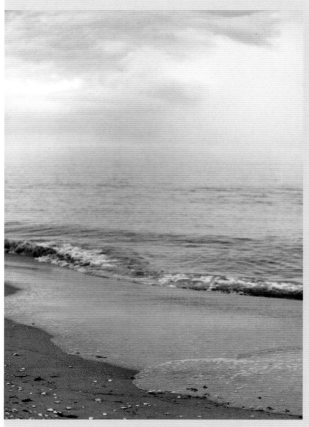

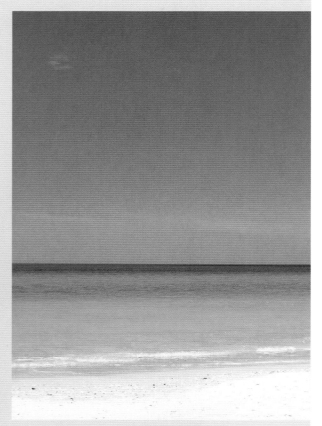

Taken on a stormy wet day, the waves rolling onto the beach together with the clouds building above create movement and interest in the picture. Even though the light looked grey and dull when I took this picture, by using curves I can enhance the actual colour that is really there, but lost to the naked eye without the sun on it.

On a bright sunny day, the colours are vibrant and the sea is calm, creating a totally different mood to the picture on the left.

16

17

18 Palm trees cast shadows on a concrete walkway, which have slightly blurred because it is a windy day, creating a softer effect.

TIP – **For abstract photos – you can photograph the light itself and the shadows it creates to gain beautiful effects – the shadows in these picture are to me more interesting than the actual objects themselves.**

This is the hall floor of an office building with the shadow of a pillar and a plant casting beautiful shadows on the tiles. **19**

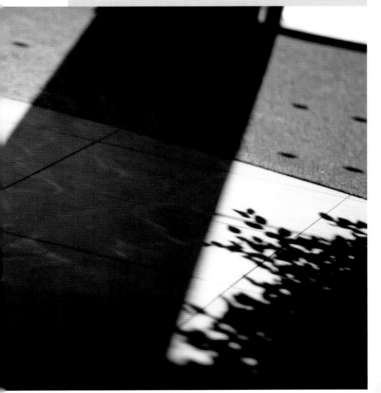

Don't worry about light – just think differently – accept the light as it is on whatever day and use it to create pictures of what you see in front of you.

Inspired by Light

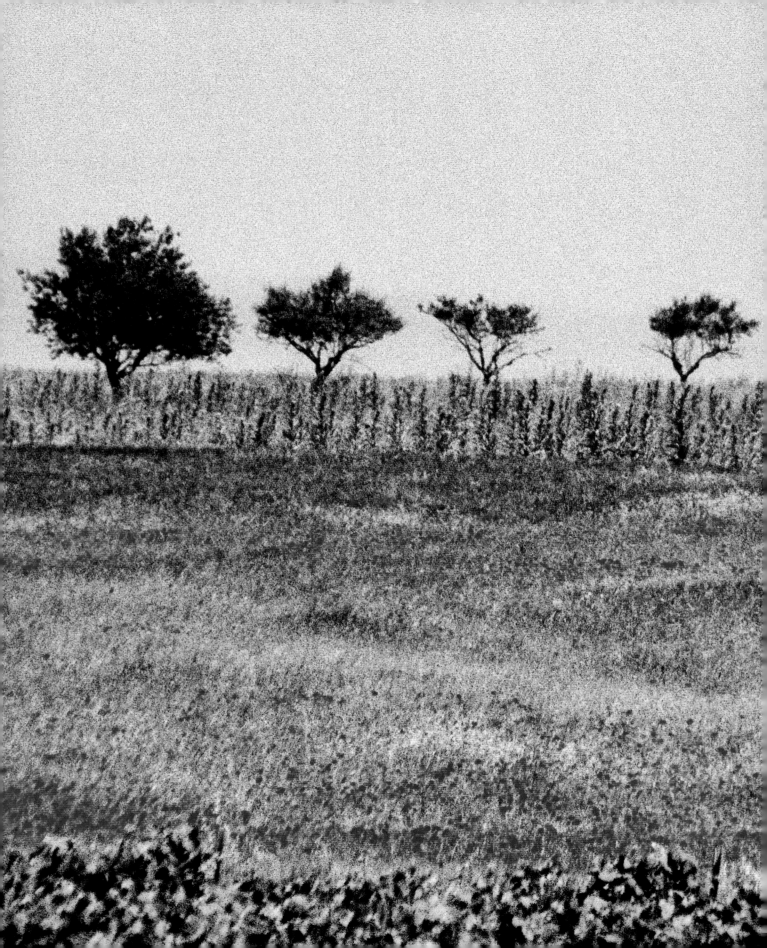

3 PHOTO ART IDEAS

1 Abstracts

2 Nature

3 Landscape

4 Architecture

5 Animals

6 Children

The great thing about abstracts is you are never quite sure what it is in the picture. Abstracts are much more fun than reality, because you can make a picture out of anything, and you usually end up with something very different from the object you started with. If your décor is mainly warm tones, then you need to look for something with warm colours from which to create an abstract piece of art for your wall.

ANNABEL'S TIPS

Look for Colour

Look for Shape

Look for Texture

This image shows a red chair reflecting its colour in the metal plant pot behind it.

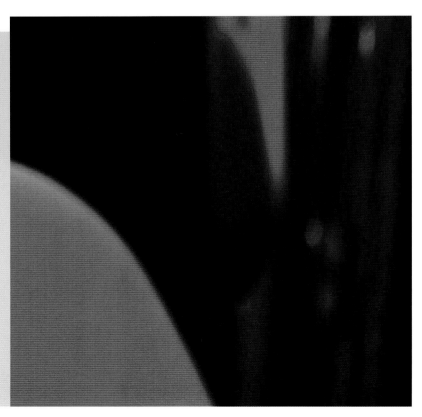

I decided to crop the image to create an abstract piece of art including part of the red chair but also its reflection behind.

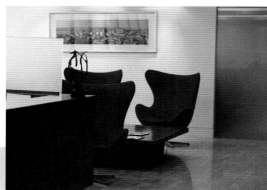

The original chairs in reception.

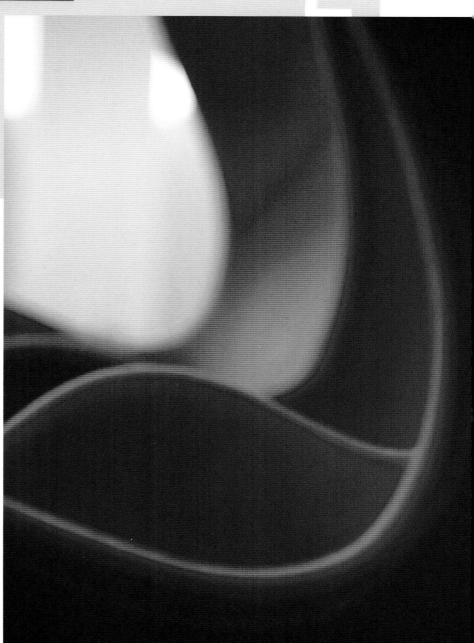

In the final shot it is no longer a chair – it is a series of curves in a dramatic red.

Shape

I was inspired by the shape and colour of these red chairs in an office reception area. I moved them around until I liked the shape they made when one was behind the other. Then on F2.8 I was able to get most of the shot out of focus and concentrate on certain areas. I love the way the curves all blend together.

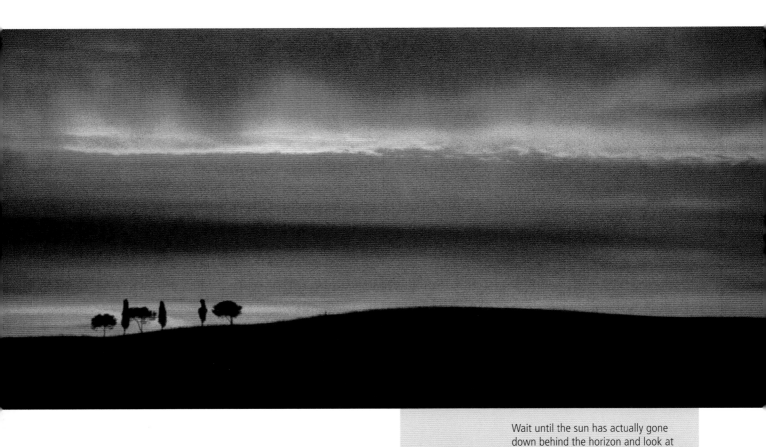

Wait until the sun has actually gone down behind the horizon and look at what it does to the sky. Find a skyline which has some interesting shapes on it, as in this shot with the trees on the hillside in Tuscany.

Colour

Adding yellow tones will always warm up a picture. Sunset shots are popular but can look too real if you just concentrate on the actual sun, which most people do. Using the effects of the sun is more interesting.

ANNABEL'S DIGITAL TIP

Film Grain

All these shots were deliberately shot on grainy colour film for an artistic effect (before digital cameras were on the market) a similar effect can be achieved in Photoshop on a digital image by using "noise" or "film grain" from the filters on the toolbar.

ABSTRACTS

You don't always have to look for landscapes; often it can be the most everyday objects that make fantastic art. This image shows crates of peaches on the pavement outside a supermarket in Greece. By cropping everything else out of shot, the effect is much stronger.

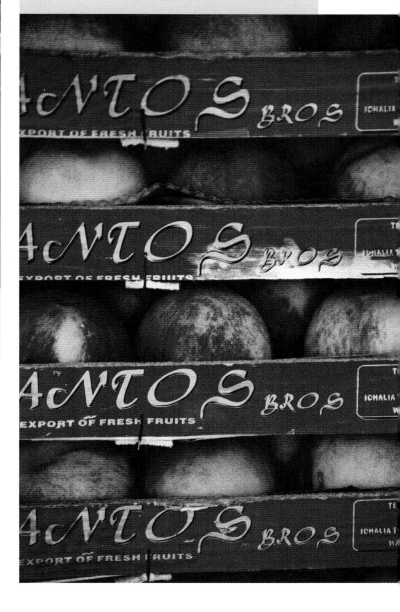

23

The evening sun is creating a soft glow on the rocks in the background, warming up the picture, and reflecting the warm red into the sea.

» By cropping everything else out of shot, the effect is much stronger.

Cool colour abstracts can be created from colours such as blue, white and ice green, among many others. Water is probably the most obvious cool colour; seascapes and swimming pools will look beautiful when photographed to suit a room with cool tones.

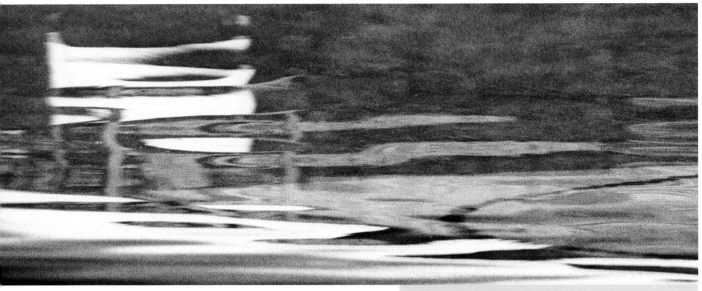

This image was taken whilst I was walking by a swimming pool during a break from a commercial shoot in Tuscany. It is the reflection of a deckchair by an infinity pool. The beautiful reflections are created because the water of the pool is constantly running over the edge creating movement and ripples.

» I love shooting reflections in water because I never know what the end result is going to be. You can compose the shot to the best of your ability but the end result will depend on how the water was moving when you actually pressed the shutter.

Inspired

The best inspiration comes when you are fresh and awake! You will be more creative when you are most receptive to your environment. What I remember most about this shot is that the day before I took it I had been lying by this pool all day and never noticed the scene in front of me! Sometimes when creative people are tired, as I was when I arrived at the hotel, they don't notice what's around them. The next day as I was checking out of the hotel, I suddenly saw what I had been totally oblivious of on the previous day! The stunning reflections in the pool. This taught me that when you're tired you're not always receptive to inspiration and the beauty of what is around you. Take a break, get refreshed, and it's amazing at how much more creative and inspired you will be afterwards!

ANNABEL'S TIPS

Often there are so many other pictures within a picture. I love the original shot, but I could carry on cutting up pieces of it forever and hanging each one individually as art in its own right. Whenever you take a picture, look at all the details in it – you will often see more.

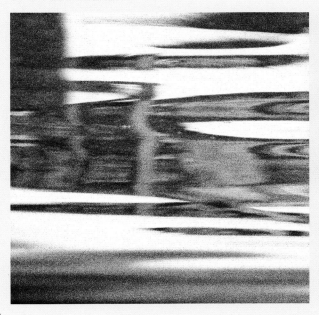

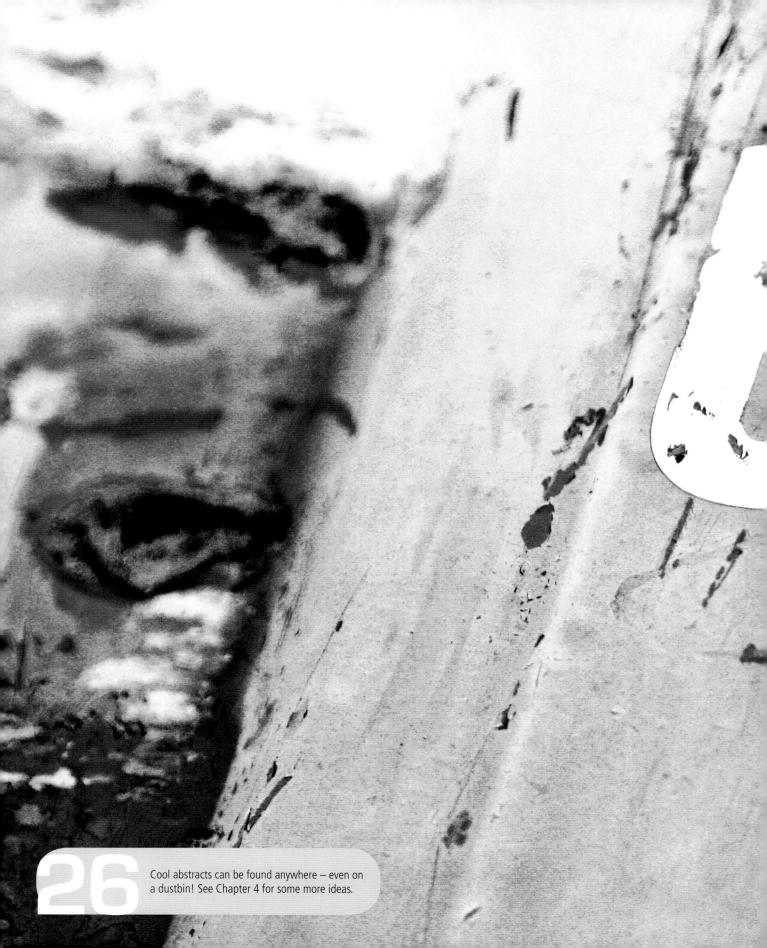

26 Cool abstracts can be found anywhere – even on a dustbin! See Chapter 4 for some more ideas.

Cool Textural Abstracts

Look for different textures when creating abstract art. Try rough and smooth, hard and soft, sharp, scratchy, bumpy, pitted. Experiment with shooting textures from the side rather than straight on because you will emphasise the texture more by doing this, and if you shoot at F5.6 the background will become more blurred and soften other parts of the picture, making the texture even more apparent.

27

By zooming in close and enhancing the colours in curves, the texture of the plant is even more dramatic.

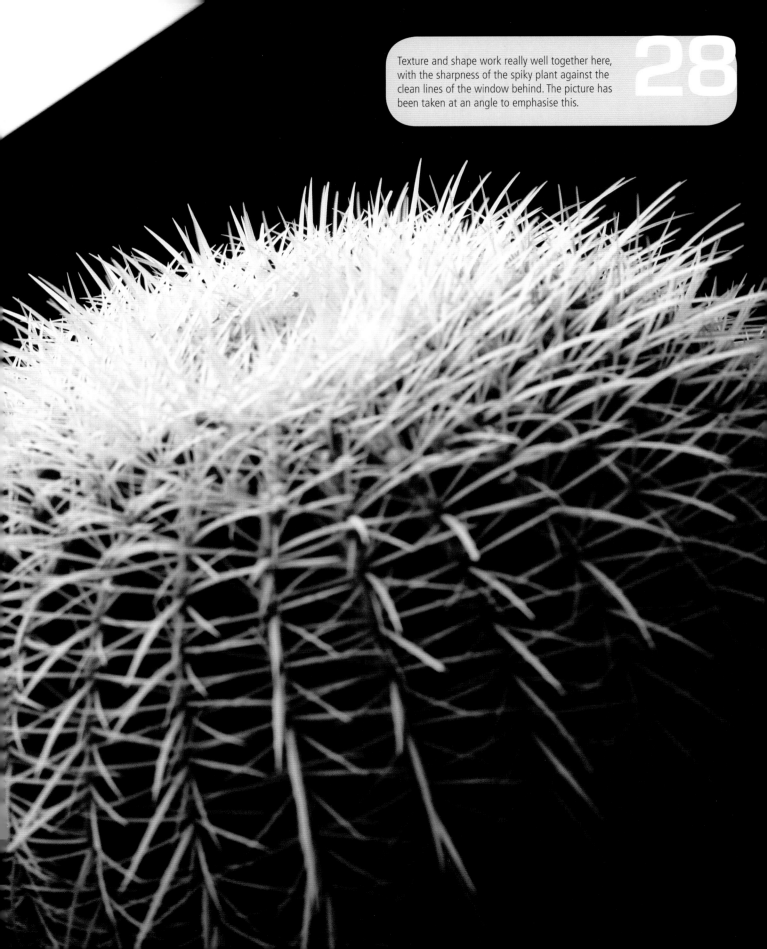

Texture and shape work really well together here, with the sharpness of the spiky plant against the clean lines of the window behind. The picture has been taken at an angle to emphasise this.

Don't just look at the object in front of you – look at the shadows it casts. On a bright sunny day you will have plenty of opportunity to look for shadows.

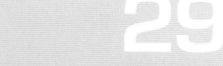

ANNABEL'S TIPS

Move the Object!

If the shadow falls across something that doesn't work in your picture – move the object until the shadow looks better!

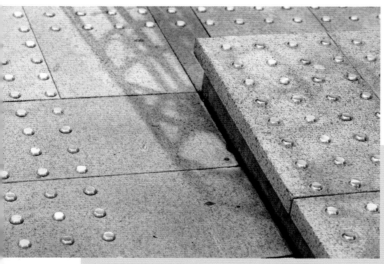

29

This is a piece of pavement with the shadow of some railings across it. By enhancing the image in curves the pavement is transformed into abstract art!

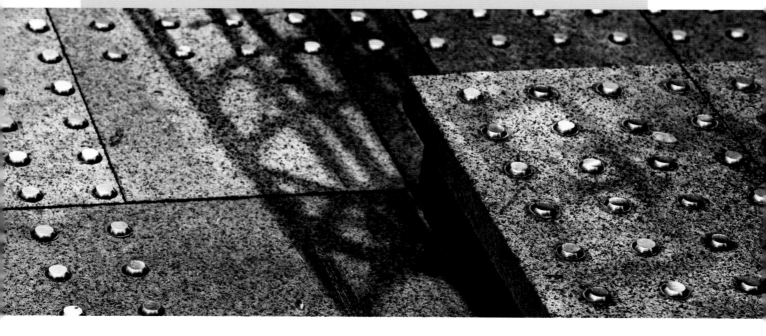

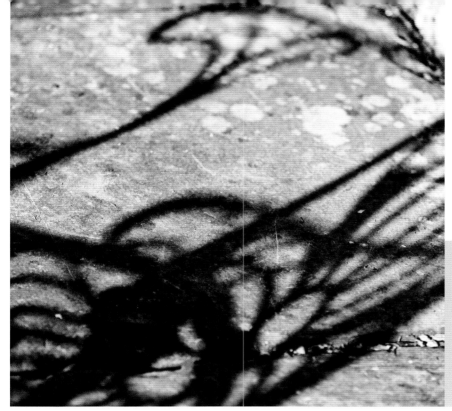

30

The object here is a wrought iron garden chair casting its shadow across a stone terrace, which has leaves and debris on it. These add to the colour of the picture and, when adjusted in curves, the shadow becomes darker and therefore more dramatic.

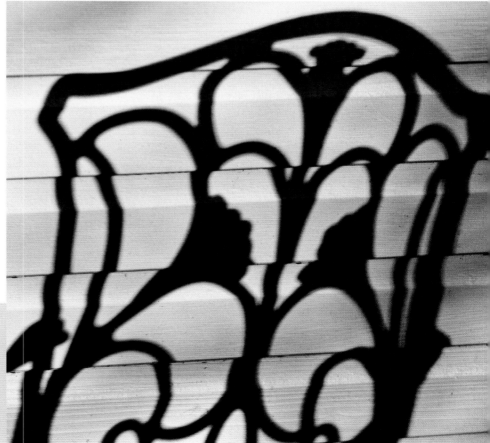

31

Here I have moved the same chair closer to the garden shed so it casts its shadow across the muted blue paintwork, creating an entirely different effect.

You can find amazing shapes and reflected light in the most unusual places. I was doing a commercial shoot for a building company when I was inspired by the light patterns and shapes in the elevator.

Shooting

Most of these pictures are shot with a wide angle lens (16-24mm) from the door of the elevator, looking up at the ceiling. I very rarely use anything but a zoom lens, but in this case I had no option as the elevator was too small to stand back from the shot. There was a mirror inside which reflected the light patterns, and with careful cropping I managed to get some amazing abstract shots.

32

I have rotated this shot 90 degrees counter clockwise, simply because I thought it looked more dynamic that way. Try rotating your images and see if they look better a certain way.

Even an ordinary elevator can create the most amazing pictures. Take time to look at things differently, and you can create art from the most ordinary things.

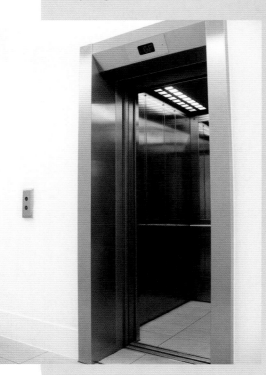

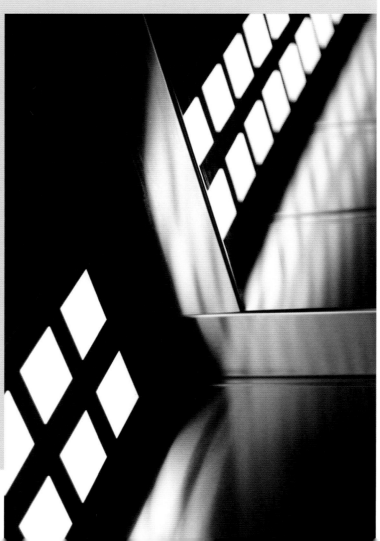

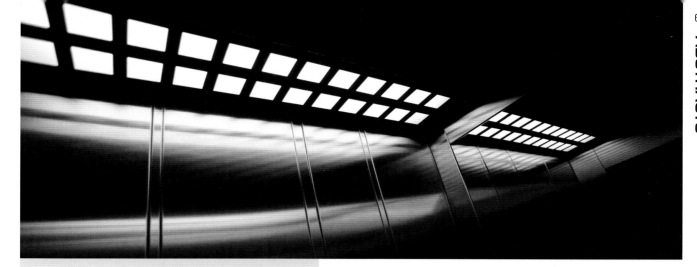

33 I have cropped this to a panoramic shape later to give a different feel to the image.

34 I have cropped this image even tighter to create a different abstract effect and enhance the square shapes.

ANNABEL'S TIPS

Different Angles

Try changing your position, and take shots from all different angles, what's in front of you might be amazing, but what's behind you might be even better!

» All these images are actually colour, but because there is no colour in the elevator, they appear more monochrome.

35 I have used curves here to increase the contrast which makes areas of the picture more interesting. The strong light on the left hand side of the picture is daylight from the windows in the hall reflecting on the metal of the elevator.

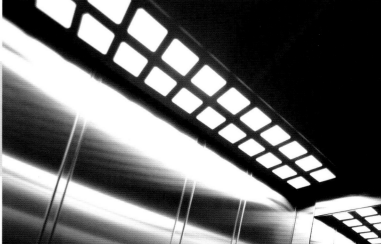

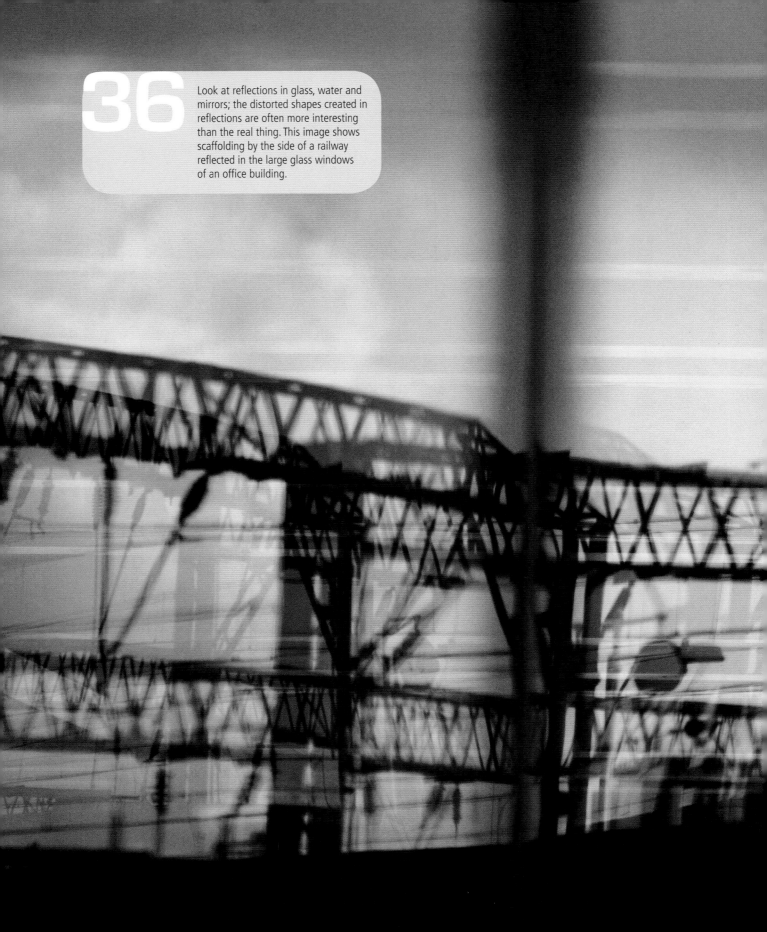

36 Look at reflections in glass, water and mirrors; the distorted shapes created in reflections are often more interesting than the real thing. This image shows scaffolding by the side of a railway reflected in the large glass windows of an office building.

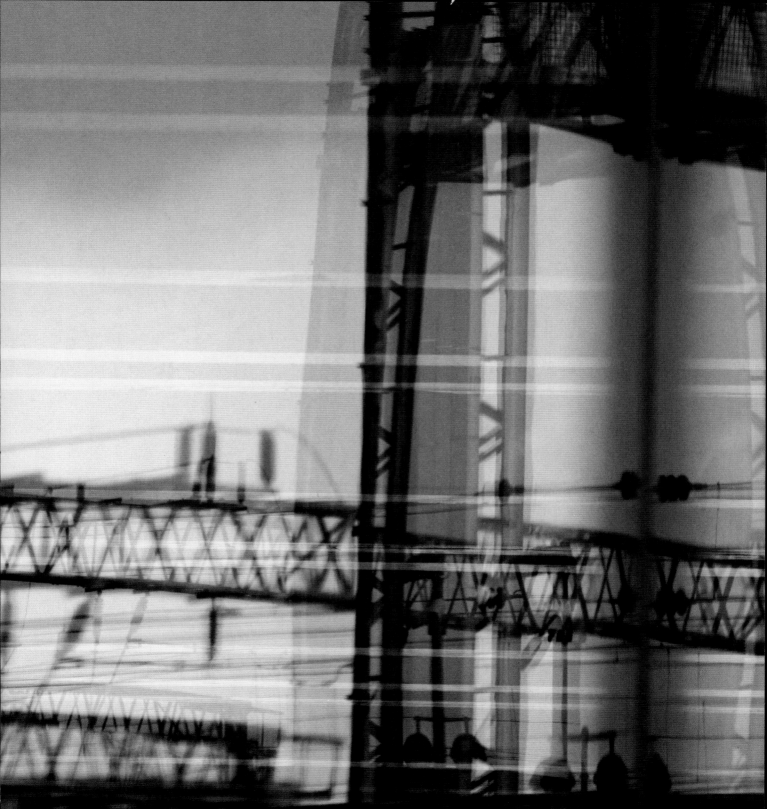

There are so many patterns, textures and colours in nature it's hard to know where to start! Most people never look further than what is in front of them, but if you take the time to go in close to nature and really study it you will be amazed at what you see.

Seeing

Try picking up an object such as a fir cone, a pebble or a piece of seaweed and stare at it for 30 seconds.

» **What do you see?**
» Stare at it again for a further 30 seconds …
» Now what do you see? It is likely that you will see much more – 30 seconds ago it was a fir cone, a pebble or some seaweed, now it will become shape and form, texture and colour.
» **Feel it, touch it, look into it, discover all its little details.**
» Look at it again – stare at it for another 30 seconds.
» By now you will be starting to develop a relationship with your object!
» Trust me, its amazing what you start to see, the longer you look at something – try it and see!
» Rather than photograph something as it looks at first sight – after you've studied it you will want to photograph it in a totally different way.

» Spend time with something like this and you'll be amazed at how attached you'll get to it!

37

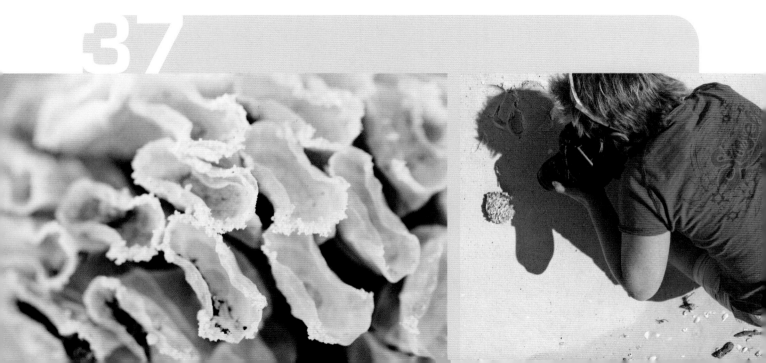

Shape

I sat and stared at this object that had washed up on the beach. The longer I looked at it the more I could see. Suddenly it was no longer real – it was all about shape and texture; I wanted to climb inside it and see what it was made of. I wanted to photograph all the little details that I was starting to see.

I liked the way all the shapes formed an overall sphere, and the more I looked at them, the more shapes and details I saw.

Inside the object it looks as if it is made up of little silk ballet shoes, and the little particles of sand look like frosted sugar around the rim of a glass. Each ballet shoe is a different shape – some are slightly folded in, others are crinkly. It makes you want to touch them.

ANNABEL'S TIPS

Macro Lens

For close up details you will need a macro lens because a 70-200 lens cannot zoom in close enough and can only focus to about 1m away from the subject. A macro lens can focus on something that is very very close to it, making it ideal for photographing the detail on small objects. If you are using a compact camera switch it to the macro setting (❀) to focus up close.

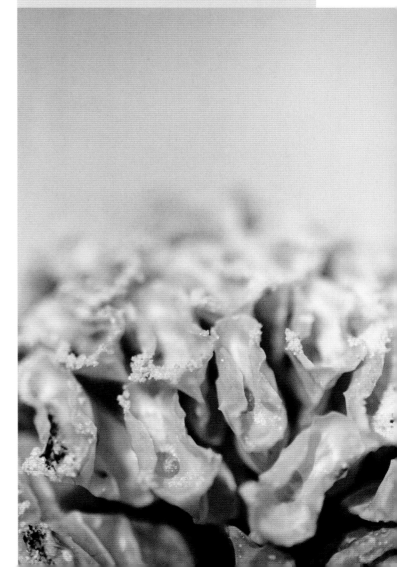

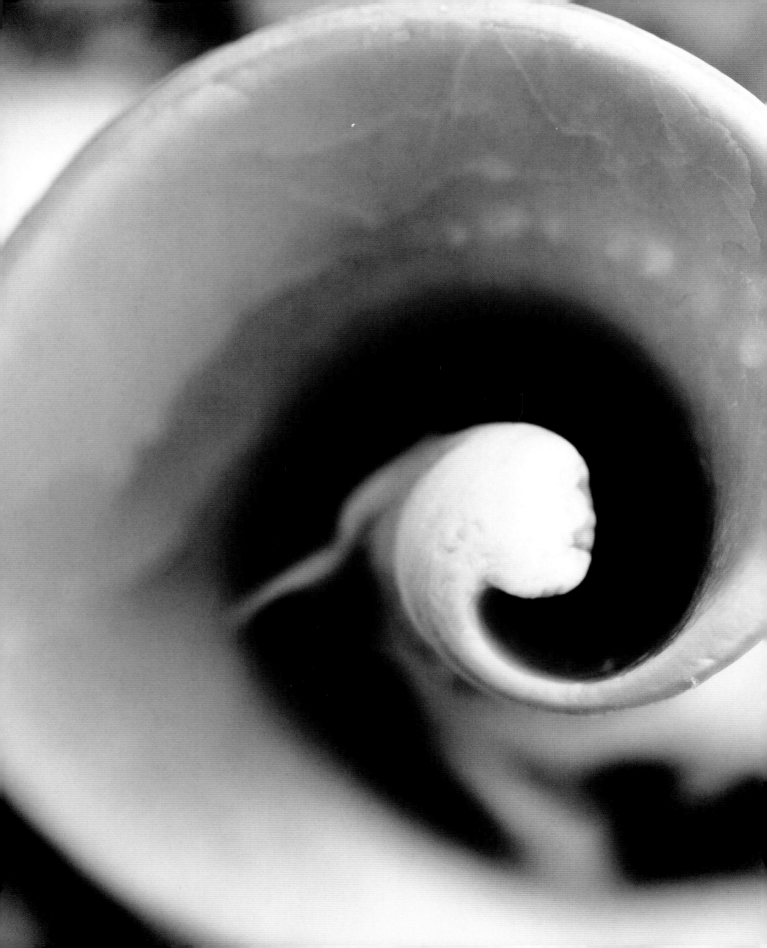

People talk about hearing the sound of the sea in a shell, but I feel if you look long enough, you can also see pictures. All that is left of this shell is the central spiral, whose shape is enhanced when photographed with a macro lens; but apart from the colours and shapes, in the centre of the spiral, I also see the head of a woman with her long hair flowing behind her.

39

If you study a shell closely you will find some of the most beautiful shapes nature has created. It never ceases to amaze me how incredible it is that nature could form something so perfect and beautiful and create so many of them in such a variety of shapes, sizes and colours.

» We are surrounded by pictures of perfect shells on beaches – most department stores have images with some variation on this theme for sale. So why not do yours differently?

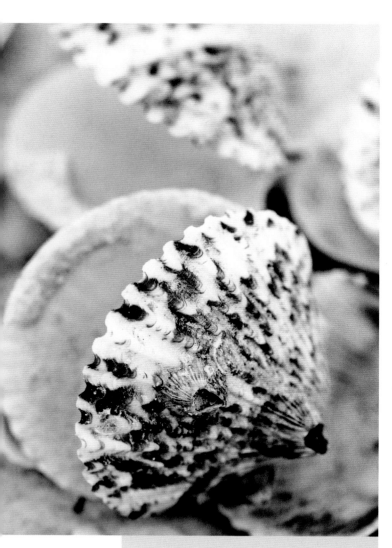

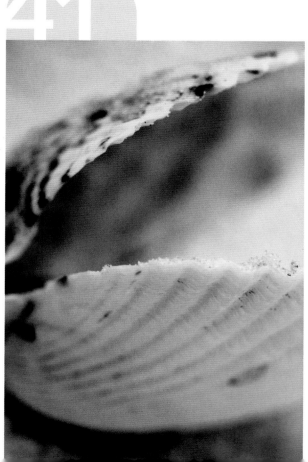

These shells are stunning, and by shooting on a macro lens at F5.6 the colour and shapes blend into each other.

40

41

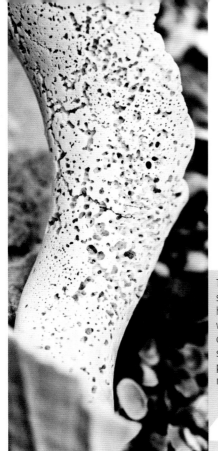

The natural shapes of the holes and sea washed texture create interesting shapes when photographed really close.

42

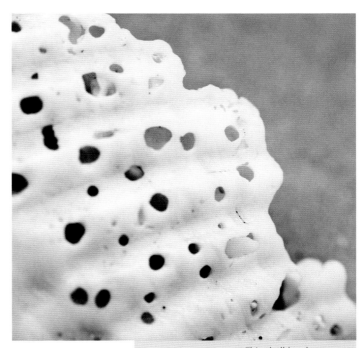

This shell has been broken but still retains its shape and texture and to me is more beautiful because of its sea washed edges and imperfections.

43

Texture

Whilst walking on a beach abroad, I eventually got bored with the perfect coloured shells, and decided I preferred the not-so-perfect broken white ones! These were huge shells, up to 8″ long, which had been washed up by the sea, broken and weathered so much that their texture was amazing. To me they were more interesting, not least because the perfect ones were in every gift shop in town and I was inspired by something that most people had ignored and would throw away!

By using a macro lens I was able to get incredibly close to the detail. I find it interesting sometimes to create a picture where it is not immediately apparent as to what it is; it makes the viewer think more, and therefore to me it becomes more interesting.

44

I felt as if I wanted to get inside the shell and see where the curves and spirals led to. I loved the texture of the edges which had broken and then been washed smooth by the sea creating a new shape and feel to the shell.

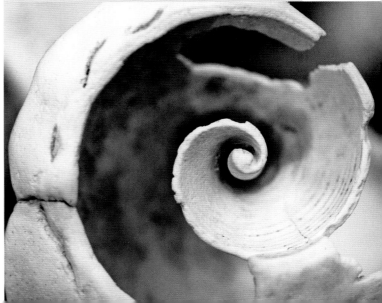

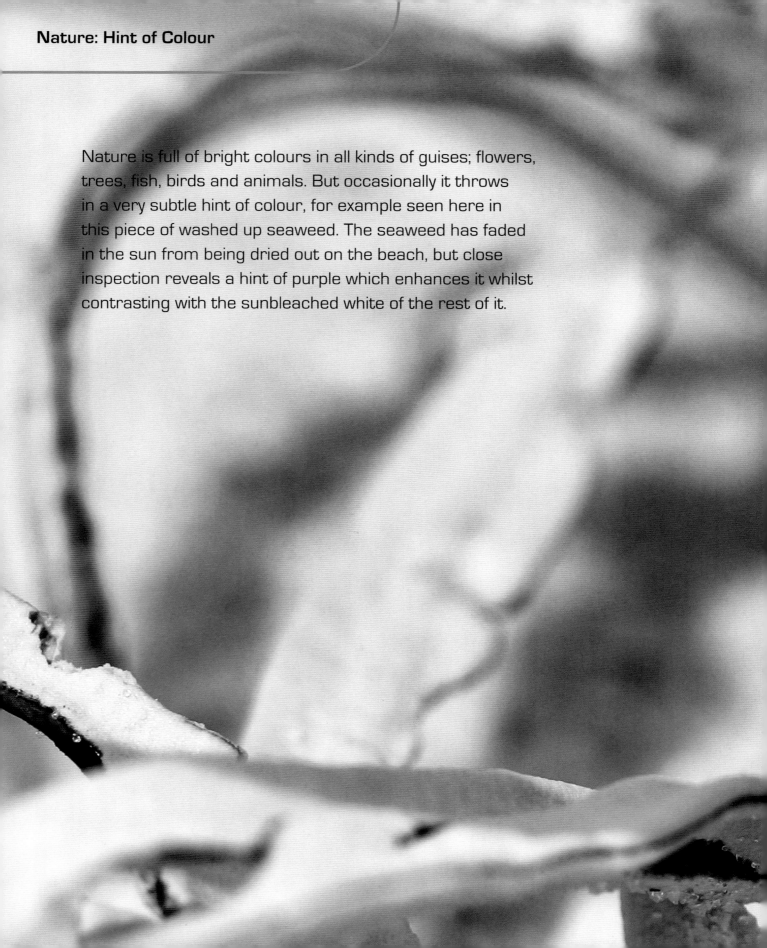

Nature: Hint of Colour

Nature is full of bright colours in all kinds of guises; flowers, trees, fish, birds and animals. But occasionally it throws in a very subtle hint of colour, for example seen here in this piece of washed up seaweed. The seaweed has faded in the sun from being dried out on the beach, but close inspection reveals a hint of purple which enhances it whilst contrasting with the sunbleached white of the rest of it.

45

A macro lens allows me to get right up to the seaweed and focus on just one single area, while the rest of the plant is completely out of focus. This works really well artistically because of the whiteness of the seaweed against the white sand, with the hint of purple lifting it. It would look amazing in a room of natural colours with a splash of purple.

The original piece of seaweed lying on the sand.

Look for lines and texture in nature. Standing back from your subject will give you a different feel to the picture. I like to stand far away and then zoom in with my 70-200 lens, shooting at F5.6, because the image is then not all completely in focus, which softens the lines and shapes in the picture and makes it look more like art than reality.

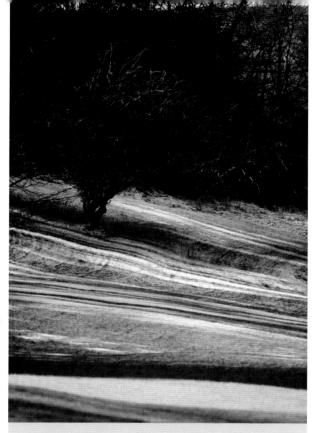

The frost on the grass created curves and lines that were very unusual and interesting. I originally composed the shot to include the tree, but later I decided to focus on the lines.

46

Lighting

These images were shot for a hotel restaurant in the English Lake District, where we wanted to bring elements of the Lakeland walls and fields into the room. It just happened that there was a hard frost that morning, which created a beautiful ethereal feel to the pictures. I couldn't have planned it – it's so much more exciting to go with the flow! This is why I say "the weather is what the weather is". If it had been a warm day the pictures would have been just as good but in a totally different way. It's part of the thrill of never quite knowing what is going to happen, and having this attitude can really add to your creativity.

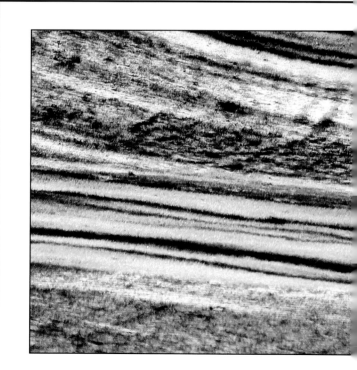

NATURE

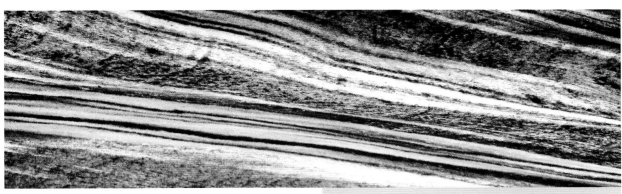

47

I cropped a panoramic shape from the original image and then lifted the curves to enhance the colour and texture.

48

I then cut the image into 3 squares to hang on the wall.

TIP - You will need to allow for the wrap-round if you are putting images like this onto canvas, and still want to see the 3 images as a whole shot.

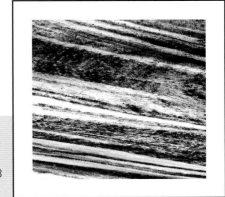

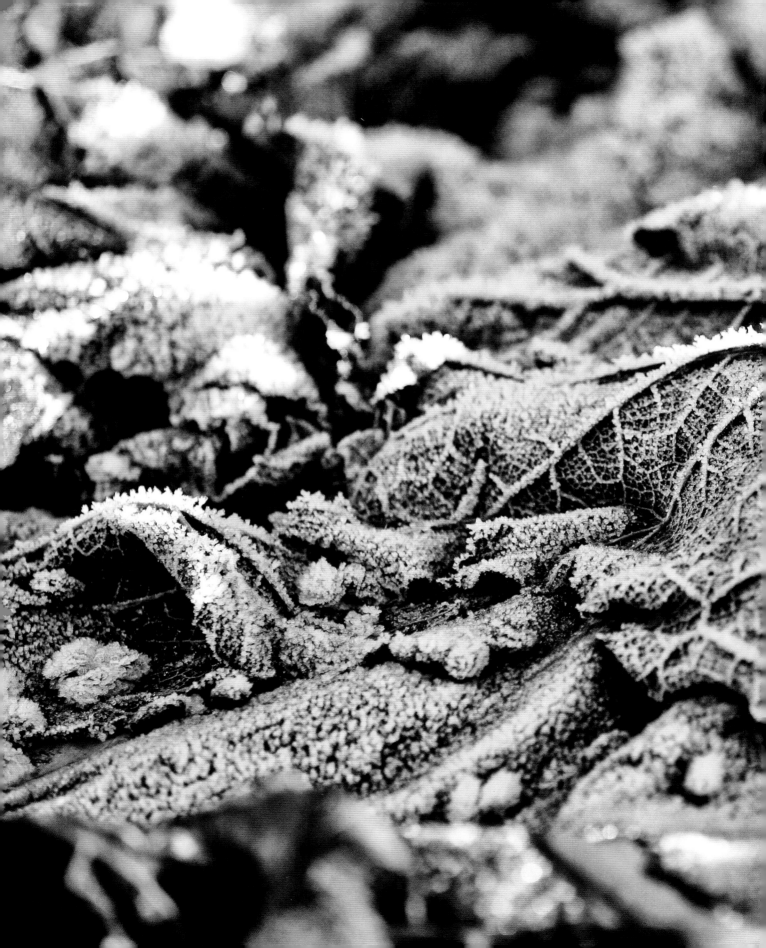

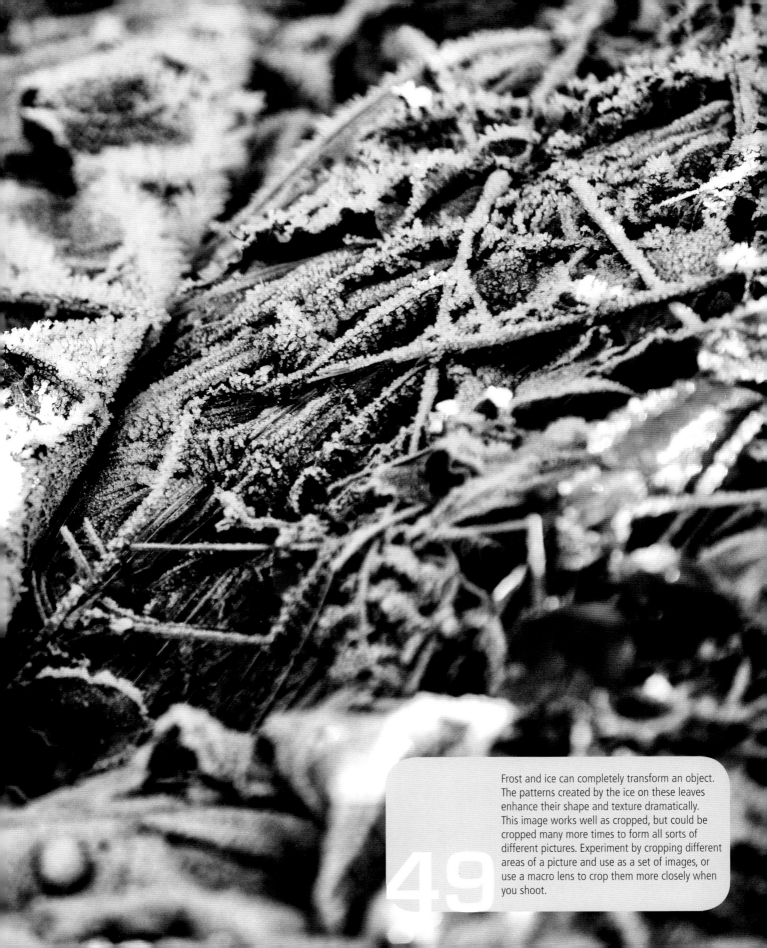

Frost and ice can completely transform an object. The patterns created by the ice on these leaves enhance their shape and texture dramatically. This image works well as cropped, but could be cropped many more times to form all sorts of different pictures. Experiment by cropping different areas of a picture and use as a set of images, or use a macro lens to crop them more closely when you shoot.

49

Try looking at flowers as shapes, rather than flowers!
Different varieties of flowers will dramatically alter the look
of a picture. A bunch of daisies would look very different
from a large hydrangea head for example.

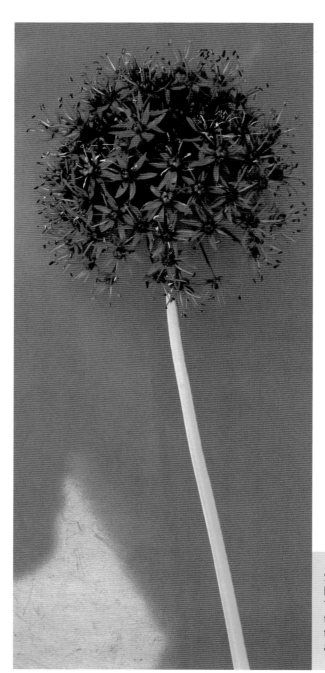

» Decide what shape of flower appeals to you.

» Do you want more than one flower in the picture?

» Experiment and see which you prefer.

Shooting

Sometimes the simplest things look the best. But it is entirely personal – you will know when it looks right, because it will feel right to you, and you will be inspired to shoot what you have arranged.

Shooting against different coloured backgrounds can have very different effects. The backgrounds here are coloured plastic tea trays, with patches of light reflecting on them. The white background is the seat of a chair.

Backgrounds

Think about your backgrounds – do you want the background to blend with the flower or contrast?

Do you want to use a brightly coloured flower against a brightly coloured background?

Or do you prefer white or dried flowers to achieve more neutral tones?

Experiment and you will get very different effects if the flowers are against a white background or a coloured background. Choose the colours which will tone best with your room.

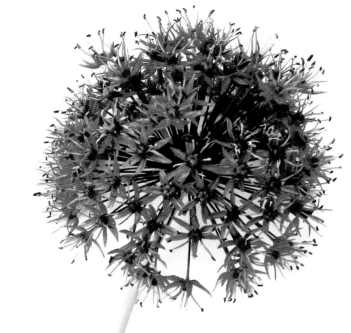

51

I chose this flower because I liked the lime green stalk contrasting with the bright purple flower. I also liked the shape and simplicity, which is why I decided to shoot only one flower rather than several, as I felt it had more impact on its own.

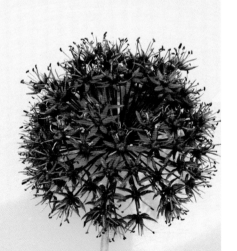

I used curves to dramatically enhance the colours, and give the flower an abstract art feel.

For a different kind of image, try concentrating on different areas of plants, rather than just the colourful petals. Look at the shapes formed by their branches.

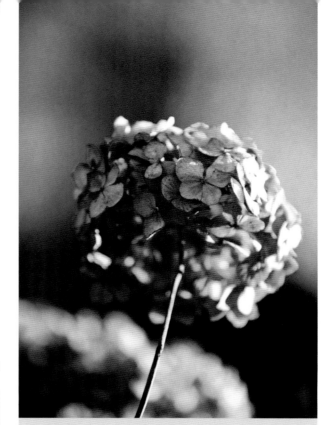

Hydrangeas look amazing in summer when they are full of colour, but don't ignore them in the autumn, when they become beautiful shades of natural browns. On a bright sunny day, their shape is offset by the blue sky. Try crouching down and shooting up towards the sky for an interesting effect.

54

This plant has tiny coloured buds, which stand out against the background because the background is far away and very out of focus. The yellow area is grass washed out in curves, and the black area is dense woodland in the distance.

53

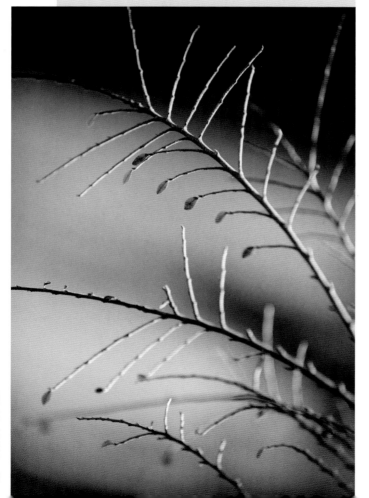

Colour

Using a long zoom lens will allow you to blur out the background and focus on the shapes of the plants. Move your position until you get the colours you want in the background. Shooting branches with pink flowers behind will give you a very different look to shooting them against blue sky for example. Choose the colours to fit with your décor.

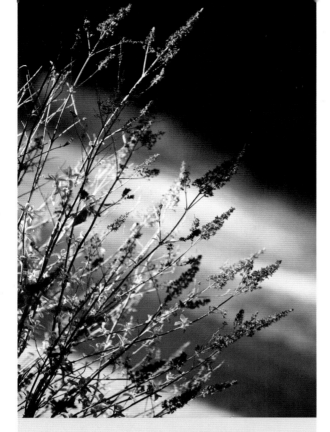

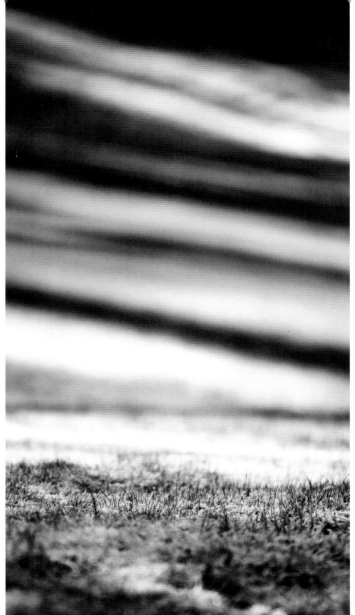

55 This plant has been photographed against frosty grass, which is out of focus and therefore emphasises its shape. I have photographed it so that it leans into the picture from the left, which works really well later when it becomes the left hand side of a set of three.

56 A bare lawn in winter provides a beautiful abstract when contrasted with the lines and texture of the frost in the background.

57 Ideas 55 and 56 are used here as part of a set of three on a restaurant wall.

Flowers have always been a good source of material for a piece of art. Their colours and shapes are infinite, and most people are naturally attracted to them. Fields of flowers are always popular for pictures on walls.

58

A closer shot of poppies among wheat, taken on F5.6 on a digital compact camera, allows the blowing wheat to be mainly out of focus with the strongly contrasting colour of the red poppies giving vibrancy to the picture. The soft quality is due to the movement of the wind through the crops creating a slight blur which really makes the shot work as a piece of art.

Shooting

I like to use my zoom lens anywhere between 2.8 and 5.6, so that I can focus on one area of the picture and allow the rest to softly go out of focus.

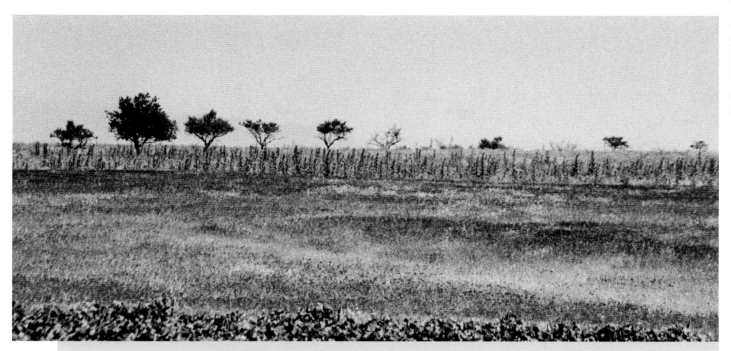

These pictures of poppies were shot in Nevada in Northern Spain – I was a long way away from them at the edge of a field, and was inspired by the landscape with the line of trees and the contrast of the red poppies against the green crops. They were also shot on 35mm film, but a similar look could be achieved by adding film grain or noise to a digital image.

59

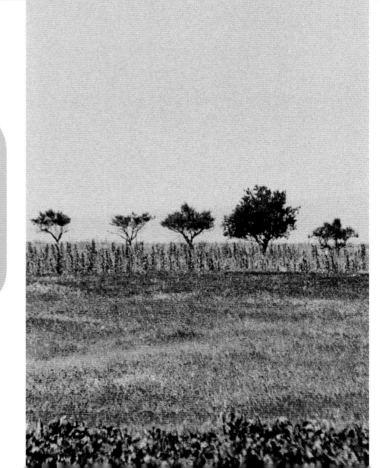

ANNABEL'S TIPS

Cropping

Experiment with your cropping while shooting – it will give you more choice when deciding which walls to put them on later, as some shapes will fit better than others on certain walls.

Composition – Horizon Lines

When composing pictures of the sea, look for the natural lines. There is usually a line of sky, a horizon line, a line where the white surf washes onto the beach, and then the line of sand. Don't be afraid to experiment and try lots of different options. Then when you get home, look at all the shots, and usually one of them will stand out to you as being better than the others.

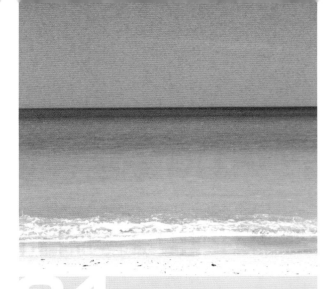

61 Try cropping the image in a square, and see if you prefer this.

60 Decide where you want these lines to be in your picture – do you want the horizon line central – higher or lower? Try taking a few different shots and see which one you like.

» Remember – if you think the composition feels wrong, change your perspective until you feel it looks right.

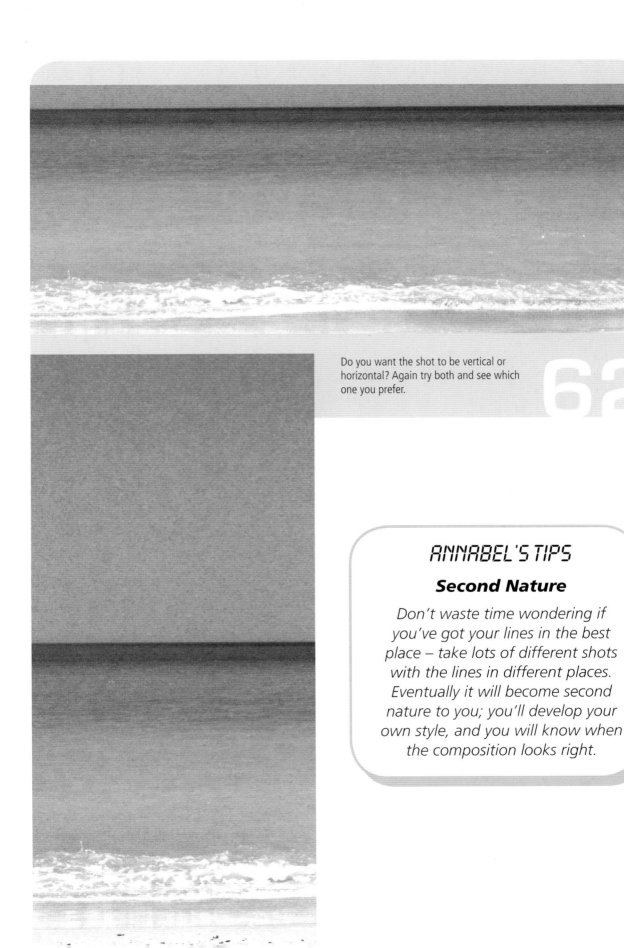

Do you want the shot to be vertical or horizontal? Again try both and see which one you prefer.

62

ANNABEL'S TIPS

Second Nature

Don't waste time wondering if you've got your lines in the best place – take lots of different shots with the lines in different places. Eventually it will become second nature to you; you'll develop your own style, and you will know when the composition looks right.

Black & white images can vary dramatically, from stark contrasting tones to warmer sepia tones. And one of the current trends in black & white is actually black & white with a hint of colour tone coming through; a look I call 'vintage' for no other reason than it reminds me of a modern version of colour washed black & whites of the Victorian times.

The original image shown here on the facing page was taken in Northern Spain and was shot in colour. I have taken the image and done 3 different 'black & white' treatments of the same shot, showing just some of the different effects that can be achieved.

63

The original image.

Digital

Black and white photos are very popular as art as they tend to fit in anywhere, with any colour scheme or décor. Black & white images traditionally tended to look more arty than colour ones until the invention of digital cameras and Photoshop which has changed all that. As with most things, trends constantly come and go and at the time of writing, we are currently in a 'colourful' trend, where many houses are decorated with an abundance of colour. However, this will all change again in the future!

This shot is a true black & white version achieved by using 'gradient map' in adjustments.

64

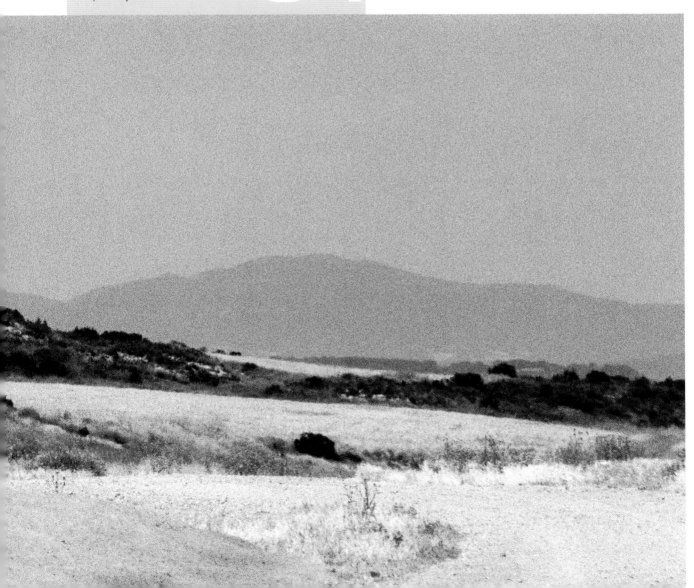

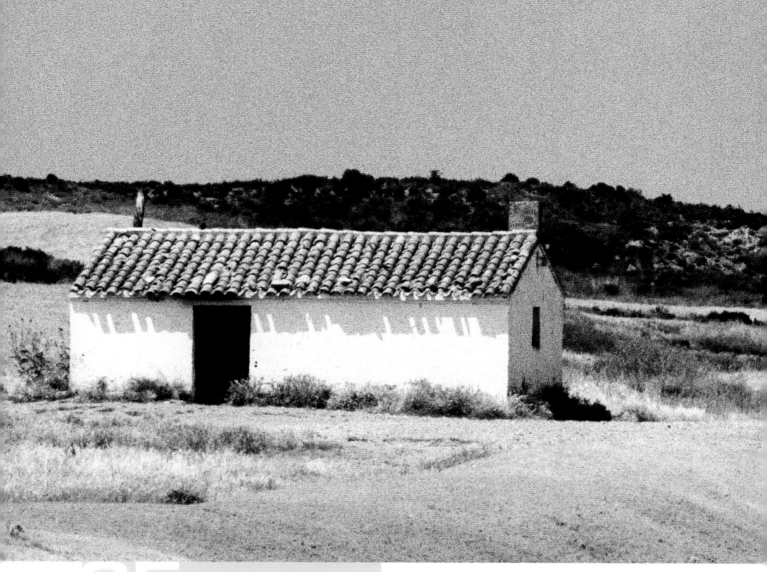

This shot shows the 'vintage' look and makes the image look more timeless.

65

ANNABEL'S DIGITAL TIPS

Create a 'Vintage' Look

1 Create a new layer.

2 Convert to black & white using gradient map.

3 Use the 'Opacity' slider in the layers palette to bring back in some of the colour.

4 Click on 'Layer' and flatten.

This sepia shot has been achieved by altering the saturation to leave only the brown tones in the image.

If you have a very contemporary, minimalist home, such as a city apartment, you might like to bring the outside streets into your living space. Take a look around the city from a different perspective. Instead of seeing those high rise buildings as offices and flats, try seeing them as shape and colour. Forget about what they really are, and turn them into art.

Shooting

While walking down a street, most of us look at things from our own height – but if you try looking up you will be amazed at the wealth of shapes and colour you can find above you, which you may not normally notice

Colour

If you want images in colour on your walls, then pictures of tall buildings will work best against a bright blue sky. If you want to include the sky, but don't have a blue sky today, then the images may work better in black & white. Alternatively look for brightly coloured buildings.

ANNABEL'S TIPS

Dynamic Effect

Take your photos at an angle for a more dynamic effect. Don't worry about trying to get the building straight – it will look better as art if it isn't.

67

The building appears white due to the reflection of the sun and clouds in the windows, complementing the actual clouds in the picture, against the stark blue sky.

68 This building has a green side to it, which when enhanced in curves becomes yellow, creating contrast against the blue sky. The windows also appear blue from the reflected sky. I particularly liked the juxtaposition of the old brick building in front of the modern skyscraper.

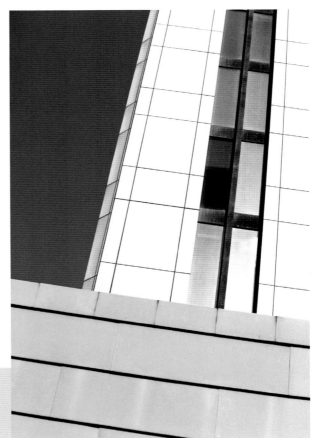

69 Here the bright colour of the turquoise tiles contrasts with the blue sky and white building above.

Look at the detail. There is so much art to be found everywhere in a modern building. Shapes, texture and colour are all around you, often in the most unlikely places.

Before

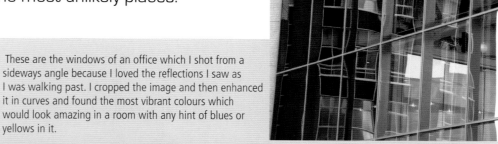

70

These are the windows of an office which I shot from a sideways angle because I loved the reflections I saw as I was walking past. I cropped the image and then enhanced it in curves and found the most vibrant colours which would look amazing in a room with any hint of blues or yellows in it.

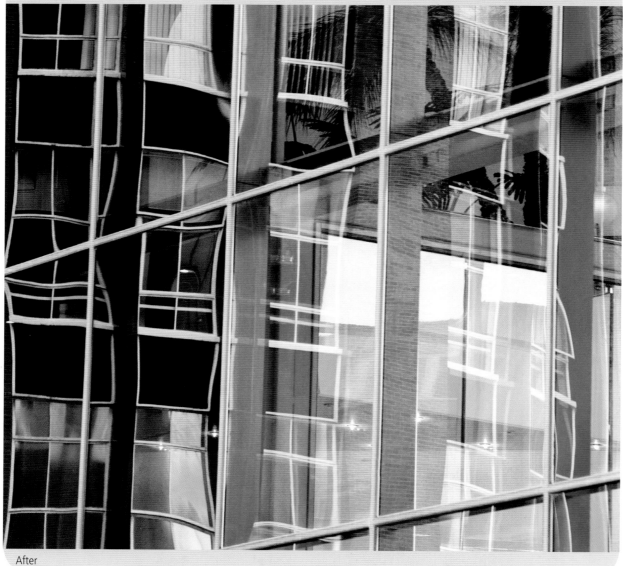

After

Before

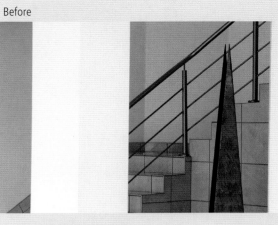

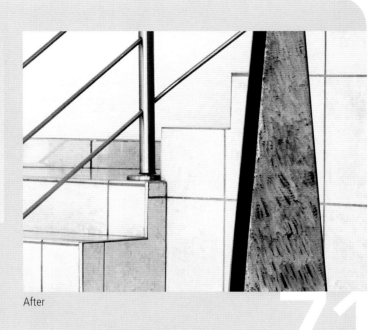

This is just the corner of a staircase in a lobby, which happens to have a triangular sculpture in front of it. I cropped the image to remove the distracting white pillars, and enhance the lines and shapes, and then lifted the curves to create this "cartoon" feel. I only lifted the curves in the same way as any other image, but because the tones of the picture are all very similar, and the lines are very simple, the resulting image was achieved very easily.

After

71

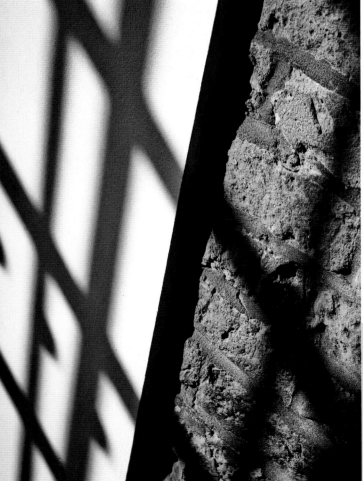

» Once you start seeing things as abstracts rather than real objects, a whole new world of possibilities opens up.

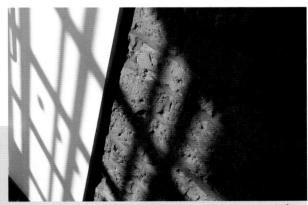

Before

This brick wall is just inside some very large glass windows, which are casting amazing shadows. Again I shot it at an angle and enhanced the curves to brighten it up.

After

72

Whenever I am on holiday I can't resist taking pictures of the old houses and buildings. I love their worn, sun-washed look, which often creates muted colours and softened shapes. These old buildings are a whole world away from the strong shapes and dynamic colours of the modern architecture on the last few pages.

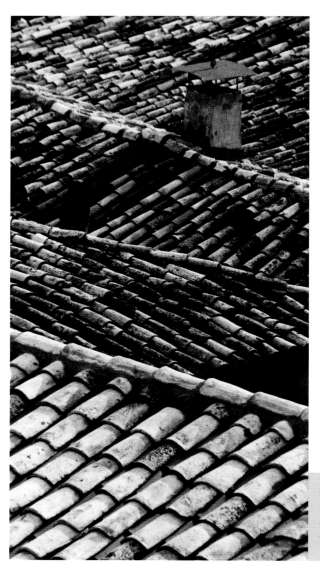

Lighting

I prefer to shoot this type of picture in even sunlight. Big shadows can spoil pictures like these, because you need the light fairly even to be able to see the detail. If it is a really bright day and there are shadows around – try excluding the shadows from the pictures, and just shoot the parts that are in sunlight.

» With careful attention to detail you can turn your holiday snaps into fantastic pieces of art.

The lines of the different roofs make an interesting composition and cropping in tightly enhances the colours and textures of the clay tiles.

73

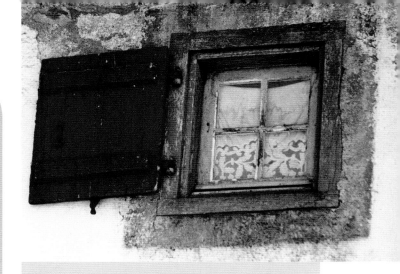

74

Interesting windows can usually be found in many old European villages. This one is particularly pretty because of its lace curtain and the soft muted colours of the old paint on the wood and the walls.

» Look for interesting shapes and soft colours.

75

I love the shape of this old wooden balcony, with its soft, worn colours, and the pegs strung out on the washing line.

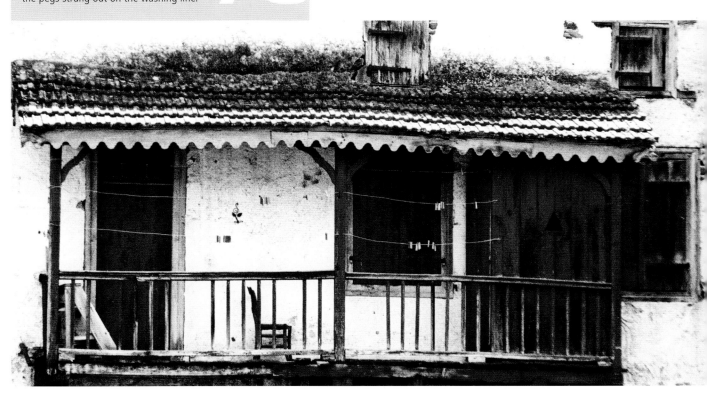

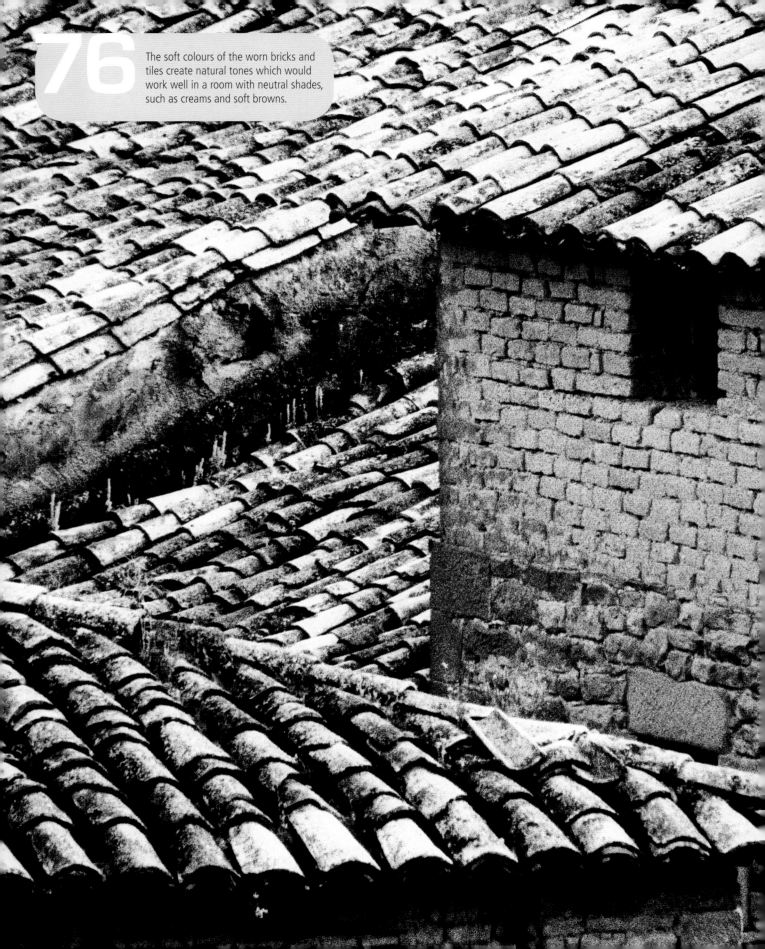

76 The soft colours of the worn bricks and tiles create natural tones which would work well in a room with neutral shades, such as creams and soft browns.

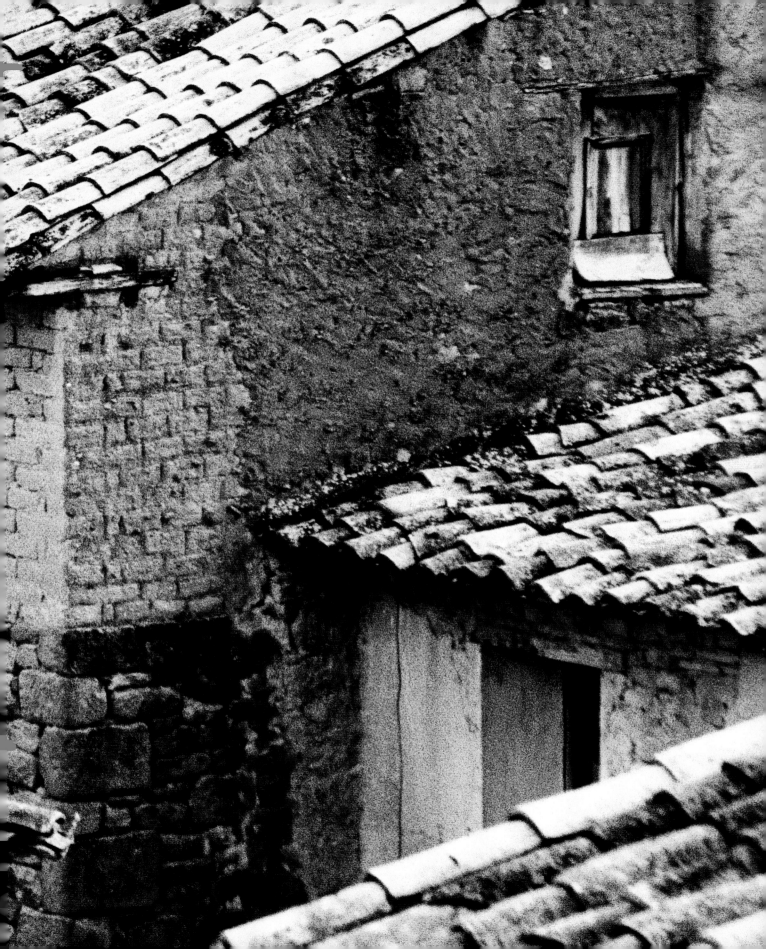

The detail of old buildings can be fascinating, because they are usually full of textures and worn sections. Whenever I am travelling in rural areas, I have a fascination for the old doors that seem to be found in every village. Many of them have new locks now which can spoil them as art, but if you look carefully you can crop these out, and every now and again you will still find one that has the old handles and locks in tact.

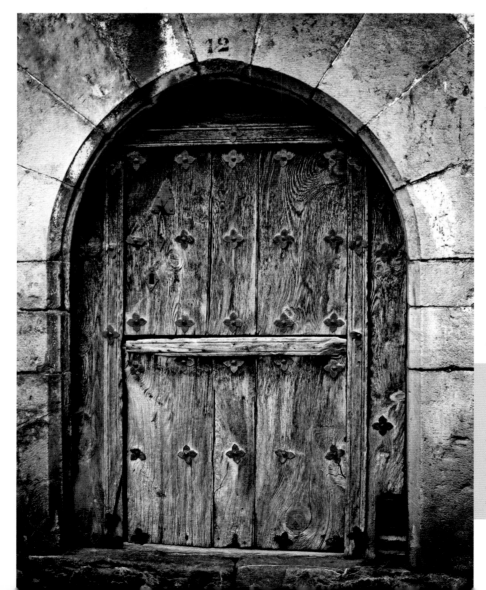

This has got to be my favourite door of all time! The door itself is a wonderful shape, but on closer inspection look at the amazing ironwork.

The texture on these old wooden doors is amazing, particularly when contrasted with the wrought iron details.

78

79

I decided to really enhance the colours in curves and in doing so, managed to brighten up the rusty metal considerably, emphasising the shapes against the texture of the wood itself.

Always being one to break every rule in the book – I have absolutely no problem working with children and animals! Yes, they can be a challenge – but they can also be fantastic fun and very inspiring.

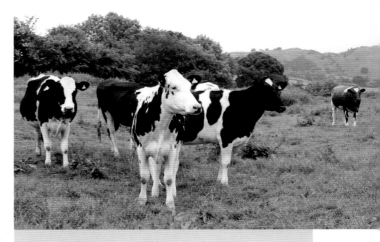

This is a fairly ordinary snap shot of cows in a field; try and think differently about what you are looking at and the difference will be amazing.

80

Shooting

Animals come in all sorts of shapes and sizes, colours and textures. Shooting a photo of an animal for your wall could either look ordinary or fantastic, depending on how you do it! For most people the animal in the picture would tend to be an animal that means something to them. Perhaps it's your cat or dog, horse or cow.

If you like wild animals, perhaps you could take the pictures at a zoo. Pictures of a tiger in the wild look fantastic in National Geographic Magazine, but are not always the best idea for an image on your sitting room wall, as realistic pictures do not often make the best art. I would much prefer to see the tiger as a shape and colour, and photograph a section of it instead. For example the skin of a leopard would look good in a room with leopard-skin patterned cushions.

Colour

Look at the shape and colour of the animal, rather than seeing it as a whole. Look at patterns and texture that inspire you.

Use a zoom lens to get as close as possible. In these pictures we are looking for the shapes in the patterns of the cow's hide.

Exhibiting

This shoot was actually done for an exhibition in an ice cream parlour and was entitled "Cows on Canvas". The main shot of the cows in the field was to set the scene and introduce the customers to where the ice cream originally came from! The rest of the pictures are more artistic, as they look at the cows as shape and colour.

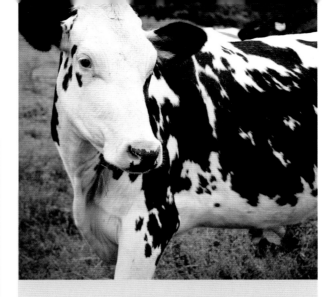

These shots are taken on a zoom lens in order to crop out the background and focus on the cow itself.

ANNABEL'S TIPS

Long Zoom Lens

You will need a long zoom lens for animals as it is often difficult to get close to them without them running away! I actually shot these pictures out of a Landrover window in the pouring rain, with a 70-200 zoom lens. Cows are naturally curious and they were quite happy to stare at me while I photographed them! Don't be afraid to zoom in really close to the animal, so that you can get the beautiful detail of its skin. The patterns on its back are very attractive and make a great piece of art.

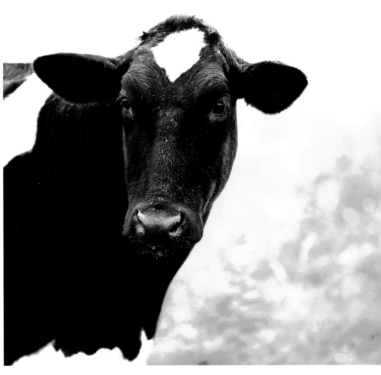

84

By zooming in close to an animal you can create a much more artistic feel to the picture. In this picture the horse is standing sideways on to me, but turning its head in my direction creating an unusual shape. It works well in this case, because the horse is very pale, and so in black & white, this would make a great piece of art.

ANNABEL'S TIPS

Photographing Horses

Horses tend to put their ears back when they are curious and unsure why you are pointing a camera at them. If you are including their ears in a shot, get someone behind you to put up an umbrella when you are ready to take the shot – the horse's ears will shoot forward! It works every time!

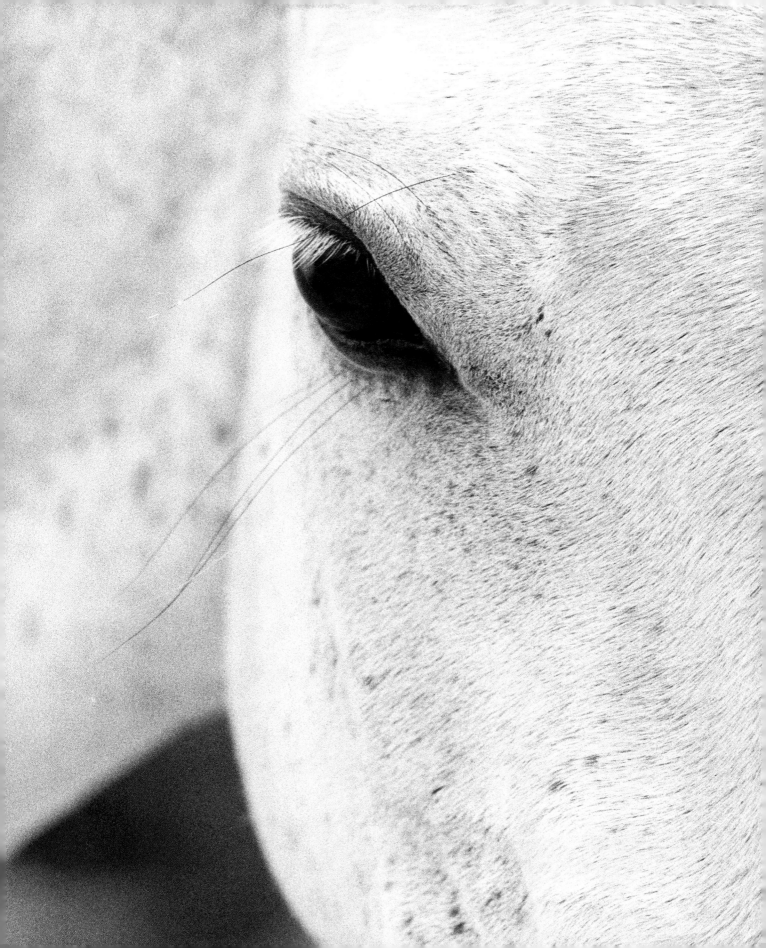

Photographing birds artistically can be challenging, but if you are in an inspiring location it makes it very easy. Taking a photo of a bird in a hedge from a hide would result in a fairly boring shot in artistic terms. So you need to find an inspiring location to start with. The beach is a fantastic place to start – as the background will look good even without the birds in shot.

Colour

I was really inspired by the colour of these birds and the way they all faced one way. I also feel the line of turquoise sea adds to the bright colours of the birds and makes the shot more interesting.

By adjusting the curves in Photoshop, I could make the image even more punchy, and create a more dynamic shot.

85

These particular birds look very cartoon like. They also stand very still and don't fly off easily! However, I was still standing quite some distance away with a long zoom lens.

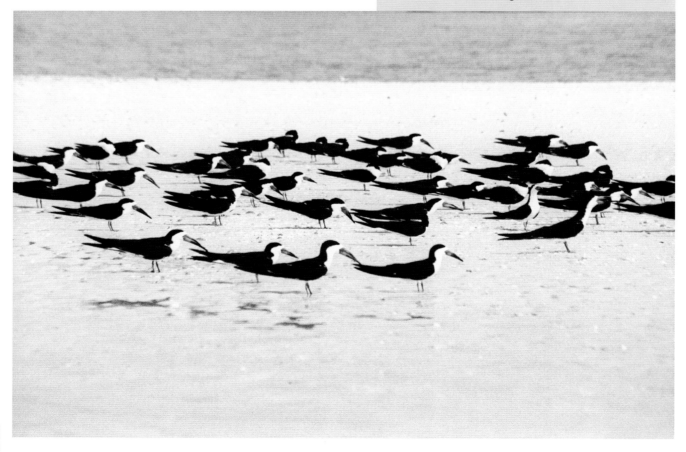

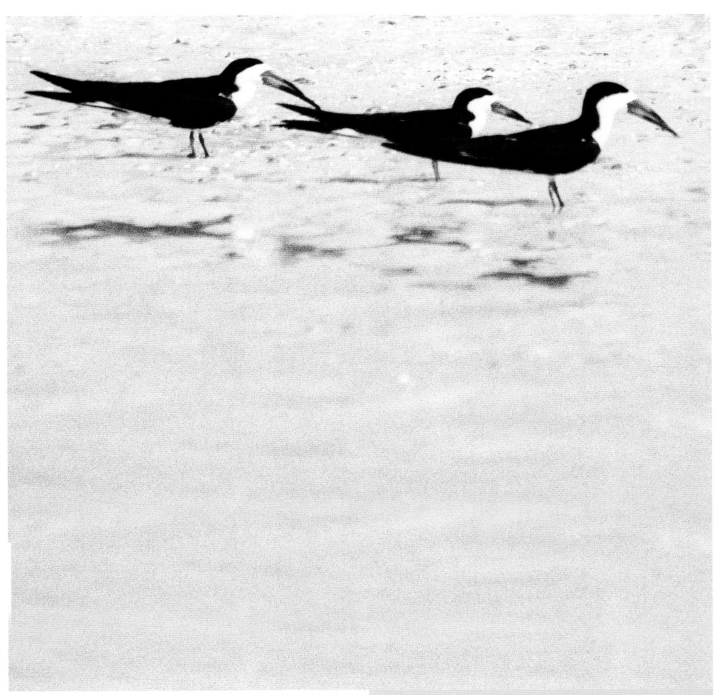

Zooming in closer I decided to compose this shot with the birds at the top and leave space below, simply because I liked the composition!

Try to see your subject as a shape rather than a bird, it will help you to create a more artistic shot.

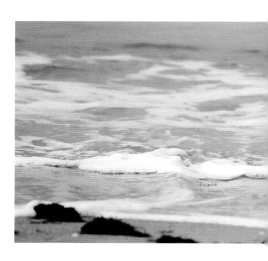

87 Here the curve of the white bird against swirling patterns of the blue water creates an interesting photo. Cropping in more tightly gives the shot a more dynamic feel than if the whole bird had been included.

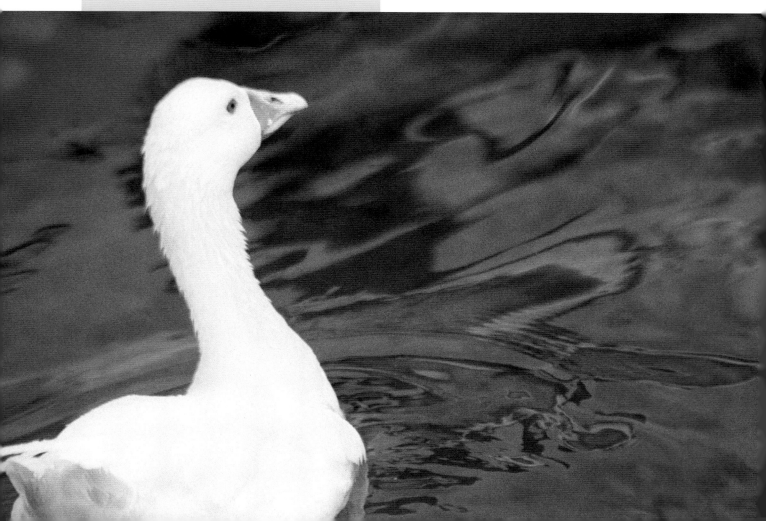

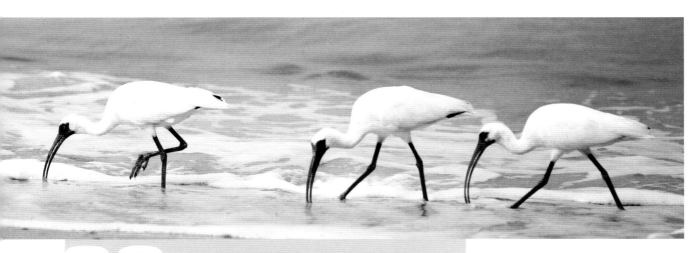

88 These wading birds create wonderful shapes in the surf. I love their orange legs against their white feathers and the water.

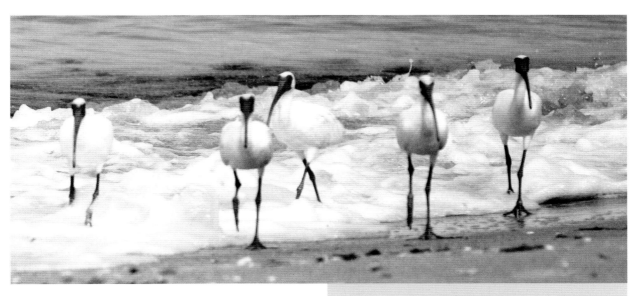

89 The birds are running away from the waves crashing onto the beach, making them look quite comical. I have made the image panoramic later, to focus more on the birds and in a room with a hint of red, this shot would look fantastic.

ANNABEL'S TIPS

Stand Still

If you don't move fast or make sudden movements the birds are more likely to stand still for you! Take a shot from a long way away in case they fly off, but then just creep up on them slowly, stopping and taking a shot each time you get somewhere near! Keep going until they eventually fly away.

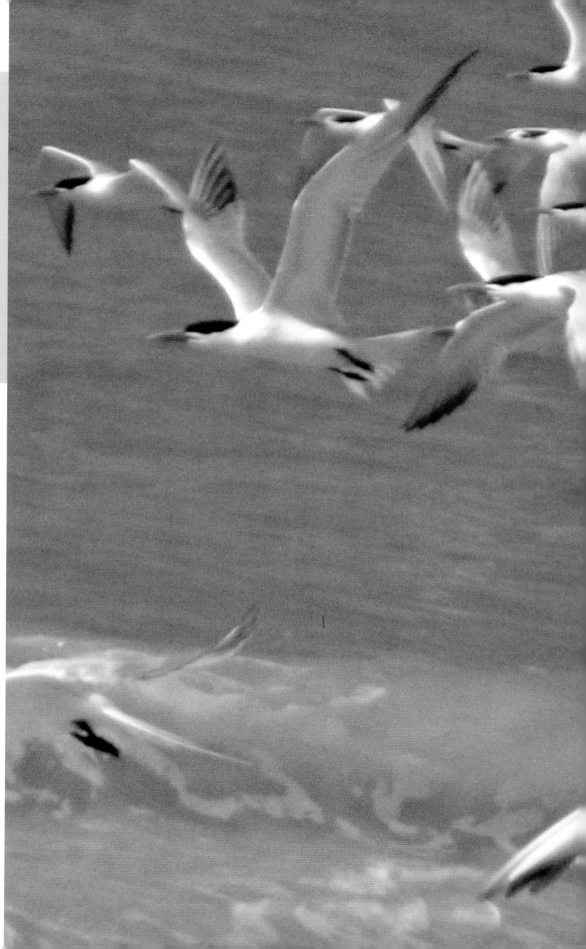

My 15-year-old daughter took this shot on a compact camera just as a flock of birds flew away, and she got an amazing picture! The camera was set on automatic, she grabbed the shot, and the slight blurring of their wings gives the picture movement and softness, which proves that if you are artistic you do not always need to have the best camera and the most technical knowledge to take a great picture.

BIRDS

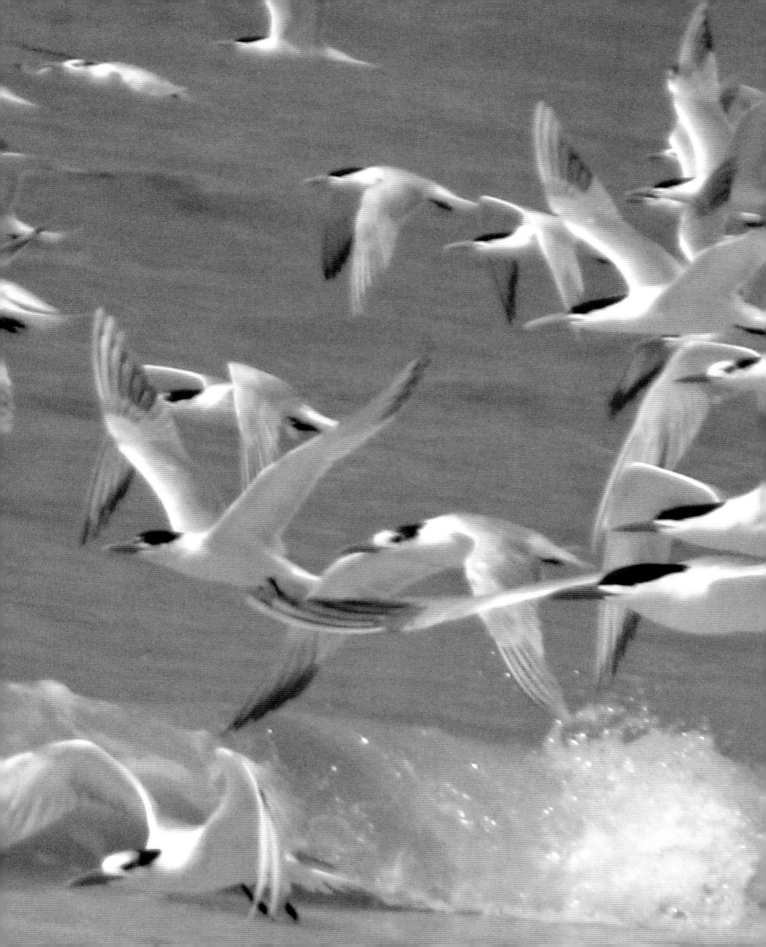

Fish are quite tricky to photograph!
I was once asked to photograph the
school goldfish early on in my career
as a school photographer, and apart
from fishing it out of the bowl and
asking it to smile I was pretty stuck
at the time! These days however I
would just think outside the bowl!
I would see it as shape and colour
and try to be more artistic. You do
not need an underwater camera and
breathing apparatus – you can just do
it differently.

ANNABEL'S TIPS

Sunlight

It helps that the sunlight is glinting on the water in the images on the facing page because it creates patterns of light which enhance the pictures considerably.

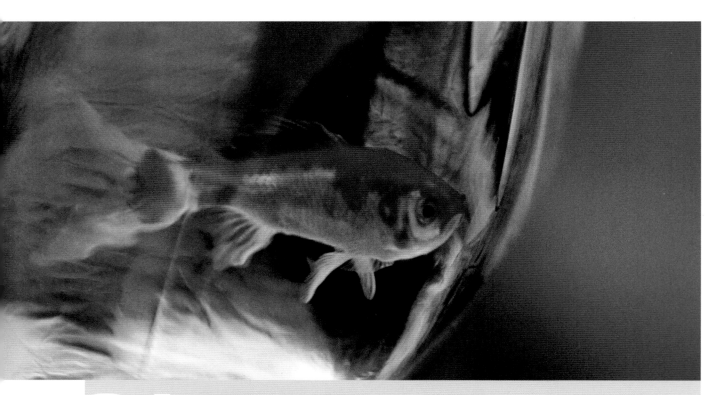

91

On a trip to a fairground I asked someone to hold the plastic bag with the fish in it in front of his jeans, so that I could zoom in. The light reflecting through the plastic creates interesting shapes against the blue of his jeans contrasting with the orange colour of the fish.

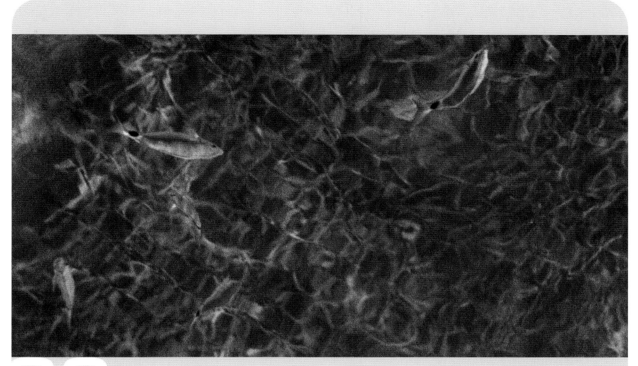

92

These fish were photographed by leaning over the side of a boat in very clear water around the Greek islands. If you sprinkle breadcrumbs onto the water the fish will usually come up to the surface and then you can photograph them swimming around. Because the water and the fish are moving, the picture has movement which makes it less "real" and more "artistic". They are also shot on F5.6 so much of the shot is out of focus, emphasising the fish.

93

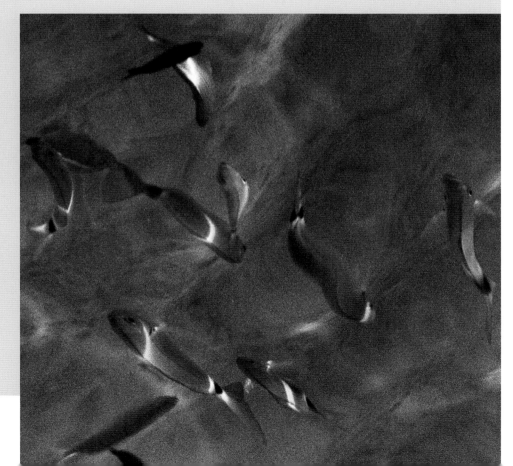

Most people take hundreds of snaps of their children and the best shots seem to end up stuck to the fridge in the kitchen, or as a screen saver on the home computer. Why not turn your children's pictures into art for your walls?

» Any picture can be transformed by enlarging it and putting it onto canvas, acrylic or into a frame, but the art will look much better if the photo is taken in the best way possible in the first place. This means placing the child in the most flattering light, thinking about the colours of the clothes they are wearing and getting them to look relaxed and natural!

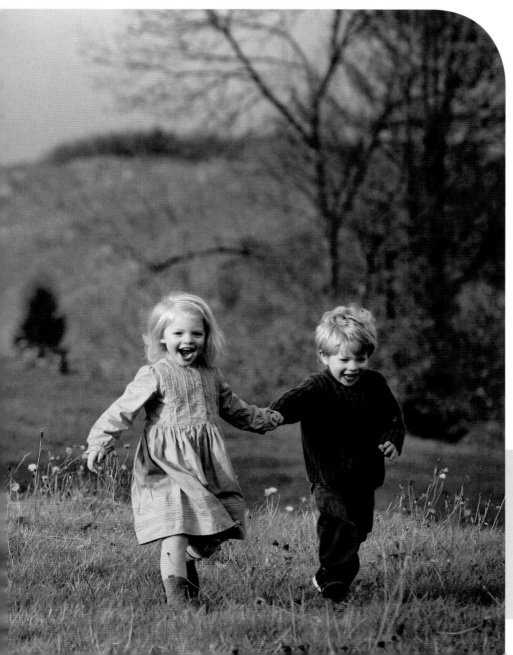

A nostalgic picture like this will be even more important in future years when the children grow up; dressing them in timeless clothes and placing them in a pretty landscape creates "a picture with the children in it" rather than just "a picture of the children".

94

Pictures which evoke memories of childhood will be even more important as a child grows up. These pictures show my daughter, Polly at the age of 5 playing on a beach. Now that she is a teenager, this image is one of my favourite memories of her childhood, and I still have it as a piece of art on my wall.

ANNABEL'S TIPS

Photographing Children

For everything you need to know about photographing children read my book "99 Portrait Photo Ideas", but here are a few tips to get you started.

TIP 1
Set your camera on F5.6 to blur out the background as much as you can – this will help to emphasise the child's face.

TIP 2
Make sure your child is in soft even light, not harsh sunlight which will cause shadows and make them squint. Soft even light can usually be found wherever there is shade; such as in a porch doorway or under a tree.

TIP 3
Decide whether you want a nostalgic feel to the picture, or a very upbeat style and dress the children accordingly.

ANNABEL'S DIGITAL TIP

Adding Noise

This image was taken before digital cameras were around, so it was shot on film, but the same effect could be achieved by changing a digital image to black & white and adding noise or film grain from 'filters' in Photoshop.

This is one of my favourite memories of my daughter's childhood, and I still have it as a piece of art on my wall.

It is not always easy to divide an image of a child into 3 equal sections; as it depends on where the child is in the picture. In this case I enlarged different sections of the picture to make it into squares; if you look closely at the original image on your right, you will be able to spot the areas that have been enlarged.

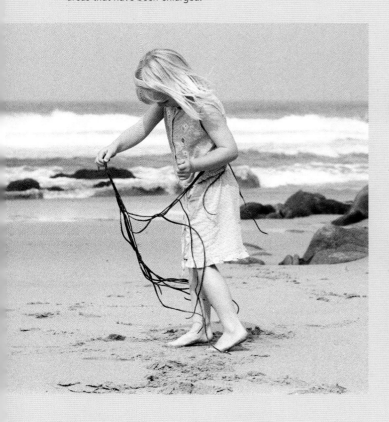

For a more contemporary up beat feel to your pictures, dress the children in bright coloured clothes, take their photos in soft even light, and zoom in to get as close as you can.

96

In these images Ayla is wearing a bright turquoise tutu, which matches the colours of the furnishings perfectly. So that when one of the images is enlarged it blends in with the colours around it and becomes part of the décor (see overleaf).

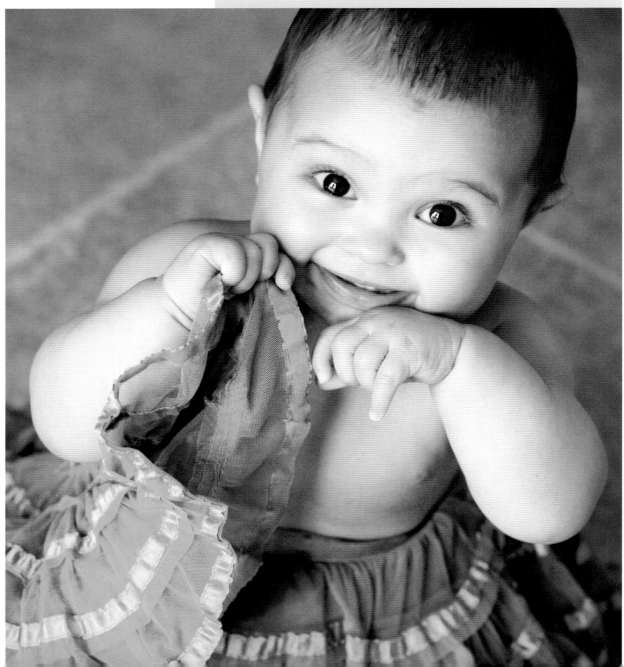

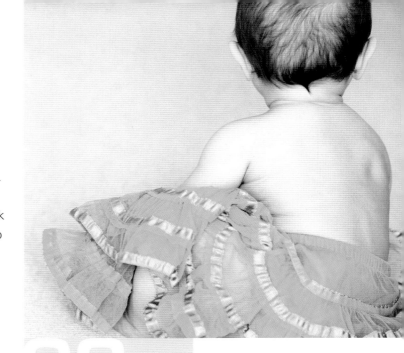

Colour
Choose a picture you can live with on your walls. Often the smiley shots of children do not blend well as art; it is the more abstract shots that work best, because they are softer and more subtle, so tend to blend into the background more.

97

98

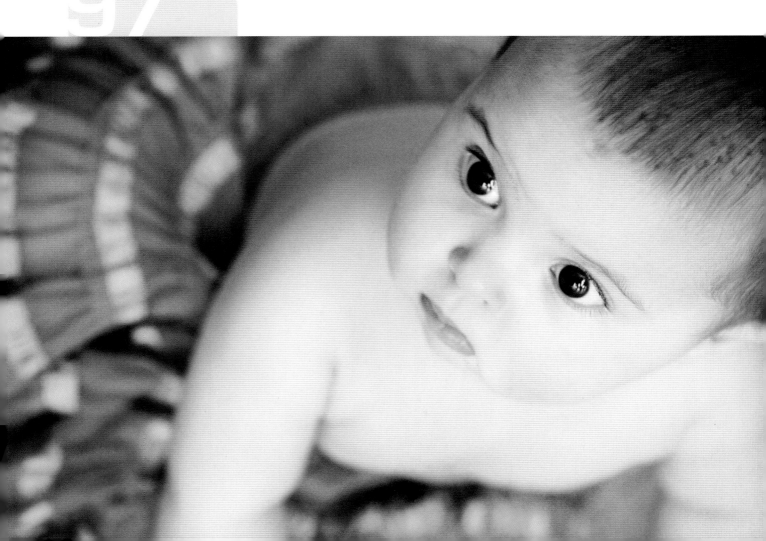

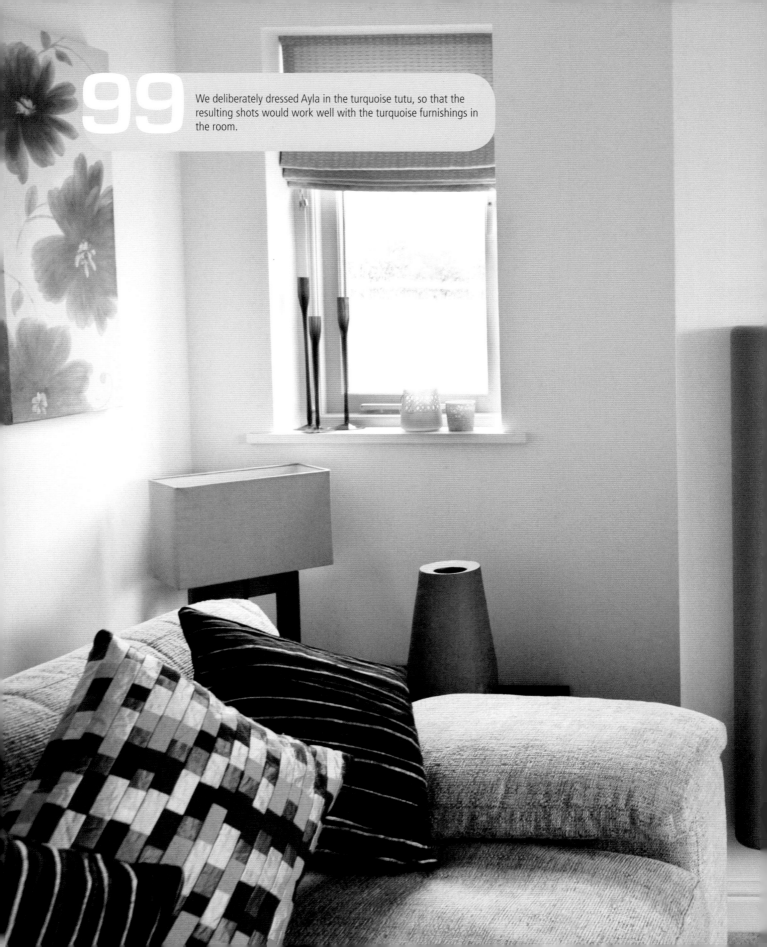

99 We deliberately dressed Ayla in the turquoise tutu, so that the resulting shots would work well with the turquoise furnishings in the room.

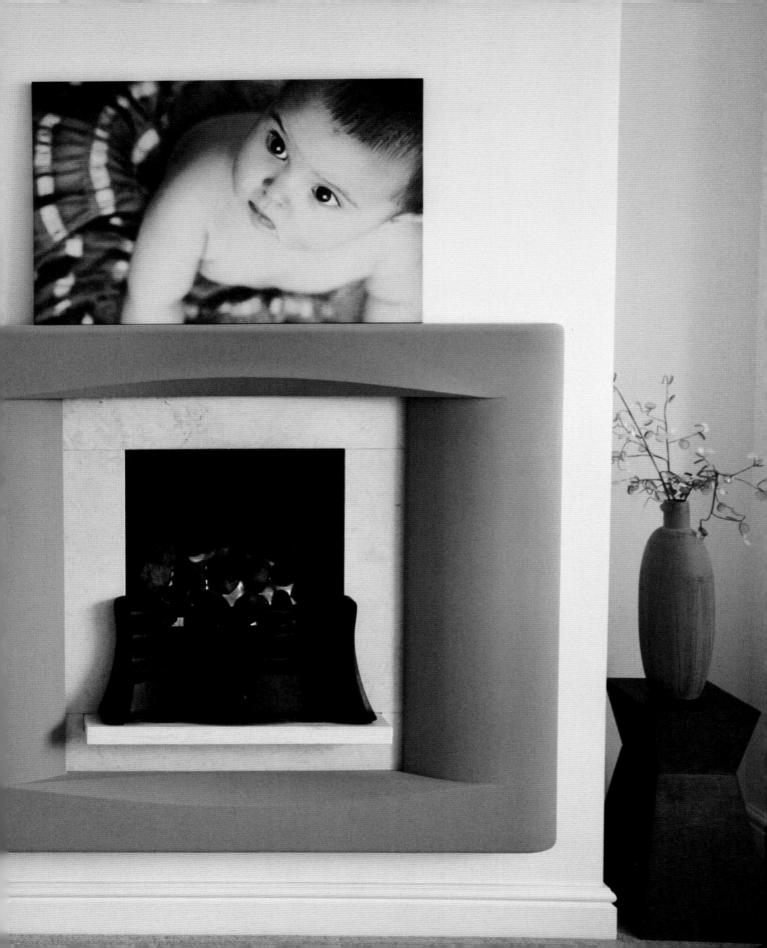

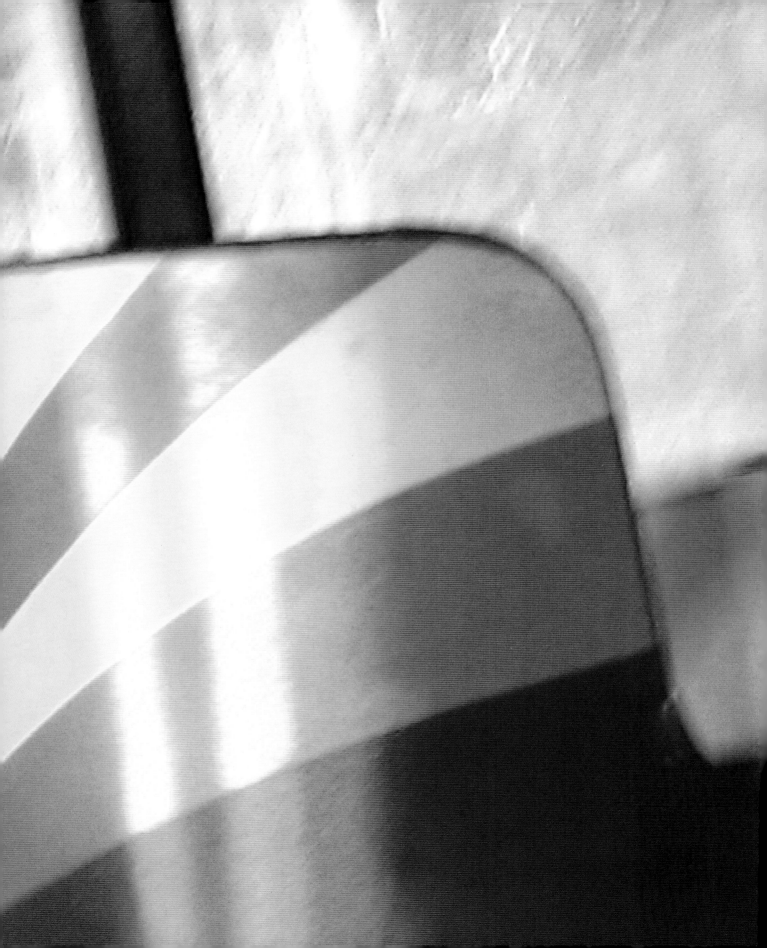

4 BEHIND THE SCENES: A REAL-LIFE PHOTO SHOOT

A Day at the Fairground
Looking for composition in details

A Day at the Fairground

Our real life shoot takes place in a small seaside town, where there are plenty of opportunities to shoot art. Ailish (15) and Niall (13) want me to teach them how to shoot some pictures for their bedroom walls, and Polly (15) has also come along with Catherine Connor to take the behind the scenes shots.

This old seaside town is now a bit jaded which is heaven to me! It provides plenty of opportunities for pictures, with its art deco buildings, graffiti walls and bright coloured fun fair rides. The new and the old are mixed together in a photographer's paradise.

» Having set our cameras up, we walk along the promenade looking for inspiration, and talking about the things we see around us.

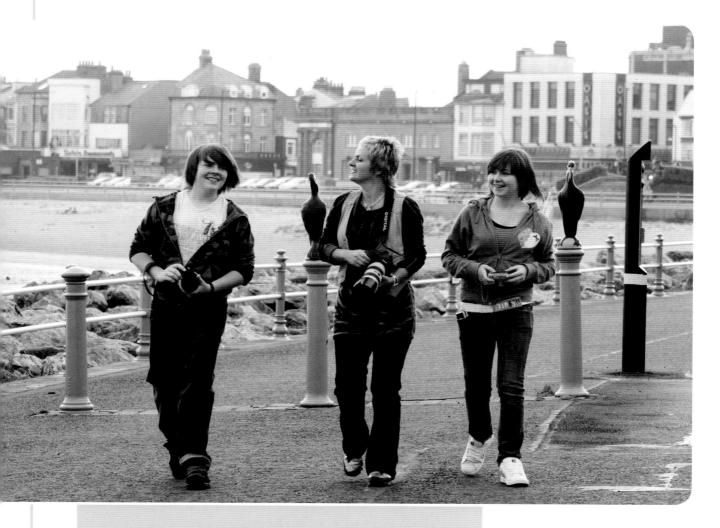

Having set our cameras up, we walk along the promenade looking for inspiration, and talking about the things we see around us.

STEP 1 – First we find an old boarded up building with graffiti, old railings and peeling paintwork. To me this is like being a child in a sweet shop – there are so many things to photograph; it's just a case of experimenting and selecting which ones work the best.

STEP 2 – Niall loves the green graffiti and peeling paint on an old wall. I explain to him that by using a zoom lens on his Canon DSLR camera he will be able to get in much closer to the image he wants to take, and by setting his aperture on F5.6 he will be able to get the background more out of focus to achieve a more interesting effect.

Niall's final image

STEP 3 – Ailish has spotted some blue railings which she is shooting sideways in order to get more of the detail out of focus in the background. Shooting straight onto the railing would create a totally different effect.

Ailish's final image

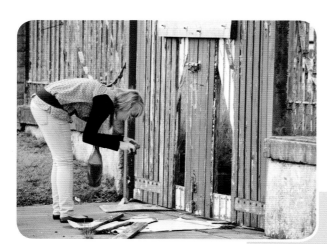

ANNABEL'S TIPS

Turn the Flash Off

If you are using a compact camera on a day which is not bright, it will often automatically fire the flash – make sure you turn the flash off by pressing the flash symbol (e.g.⚡) and hold the camera steady – the result will be far better – test it and see!

STEP 4 – Polly meanwhile has become distracted from her 'behind the scenes' shots and decided to shoot her own art too! It's no wonder – taking pictures here is very addictive!

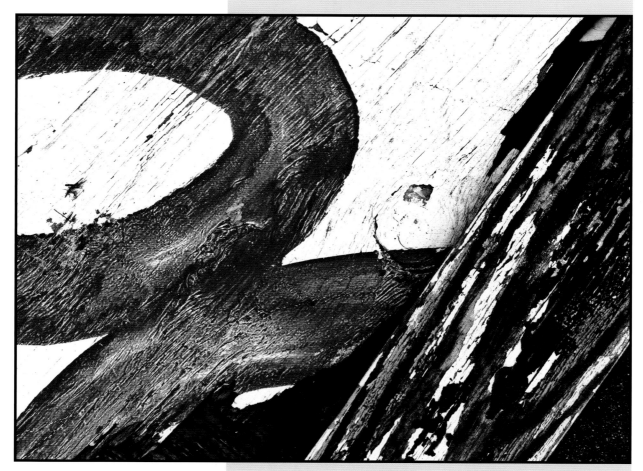

Polly's final picture

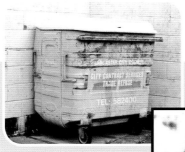

STEP 5 – We spot an old rubbish container which is covered in peeling blue paint, and I persuade them to photograph something which most people would see as an eyesore, but can in fact provide the most amazing art!

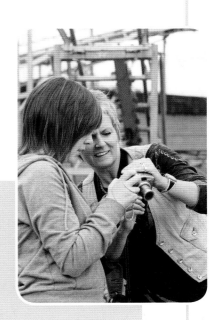

STEP 6 – I show Ailish how to use her Canon compact camera to shoot really close up and keep the background out of focus, by switching to Macro setting

TIP – Look for the flower (🌷) symbol usually found on the back of the compact camera.

We then move on and find a small fun fair which is full of bright colours and interesting patterns.

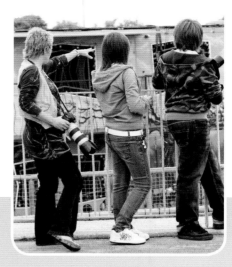

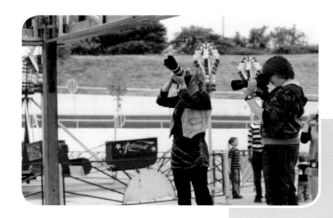

STEP 7 – Polly and Niall get inspired by the Waltzers and create some amazing shots as the chairs spin round. The slight blurring of the shots makes the pictures far more interesting than if they were completely sharp.

TIP – Make sure you turn off the flash on the compact camera, and if you can't get it to blur, set the camera to manual, and change the speed to about 1/30th – don't forget to put it back later or everything else you shoot may be blurred!

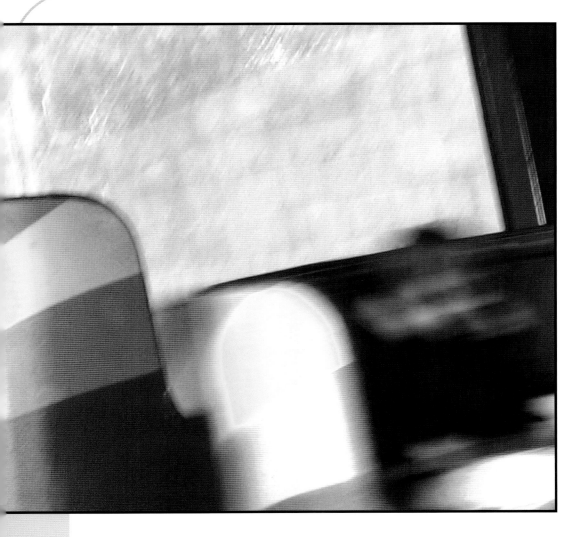

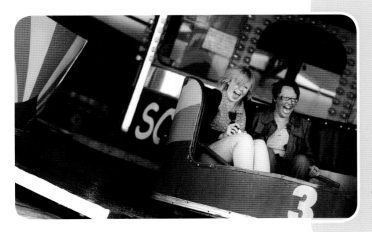

STEP 8 – We decide to take a break from shooting and go on the "very exciting" caterpillar ride! Hardly a white-knuckle experience and slightly more timid than Catherine and Polly's trip on the waltzer – but a great break in a fun day!

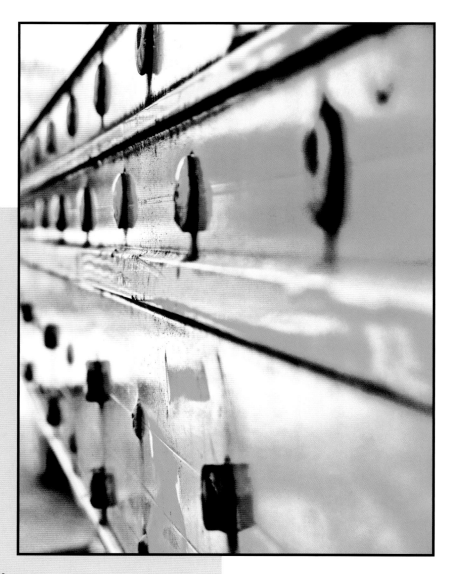

STEP 9 – Meanwhile Ailish has become very attached to a wagon trailer! She is inspired firstly by the bright blue colour, because she is painting her bedroom in a similar way, and then by the shapes of the bolts in the metal work.

STEP 10 – She then shoots the reflections of the dodgem cars in the blue paintwork. When the pictures are enhanced in curves later, they look amazing!

>> Ailish is very proud of her piece of art – the perfect complement to her new bedroom!

STEP 11 – Finally we download the images at home, select our favourites and adjust them in curves to create our own art.

5 IMAGES INTO WORKS OF ART

From Camera to Computer

How Do I Organise My Pictures?

Once you've taken all your beautiful pictures you need to get organised! With digital cameras it is so easy to be 'snap happy' and take thousands of shots that never actually leave the camera!

» With digital cameras it is so easy to be 'snap happy' and take thousands of shots that never actually leave the camera!

This is why it is so important to limit yourself to how many shots you take – it is much better to take a few good shots than hundreds of average shots! Think carefully about what you shoot, so you can save time later not having to trash so many.

Once you've set up a simple system, it will always be easy to download your images, store them, and be able to find them quickly in the future.

There are many programs you can buy that will sort and store your images for you, but I still back everything up the old fashioned way too. I would hate to think what would happen if my computer broke in the future and took all my images with it! Therefore, I initially store my images on my computer hard drive, but at the same time back everything up to DVD and an external hard drive.

External Hard Drive

When you have finished working with your images and your art is on your walls, store the retouched images on your external hard drive together with your originals, and then delete all those particular images from your laptop, in order to save space and allow your laptop to work efficiently.

Once you really get into taking photos, you will have so many images to store and your laptop will get full very quickly.

For easy storage you will require:

1 Good quality DVDs

2 DVD storage folder with stickers so you can number the pockets

3 A-Z book to file names for reference and easy identification

4 An external hard drive for storage

Organising your Images

Stage 1 – Downloading

A. When you finish your shoot, download your images to your computer using the firewire supplied with your camera, or a simple card reader.

B. Back up your images to a DVD before erasing your flash card to make sure they are safe.

C. Back up your images to an external hard drive.

>> The best way is to experiment and find out which way suits you. There is no right or wrong way – only the way you find easiest and most suitable for your own needs.

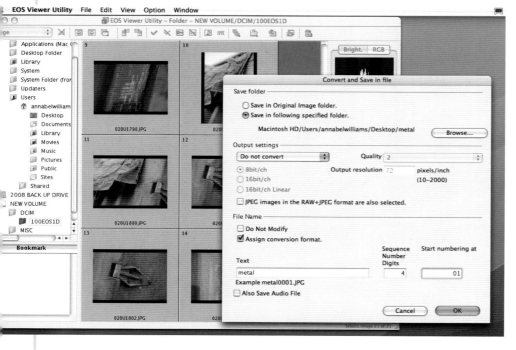

Stage 2 – Referencing

Enter the name of the shoot into the A-Z book along with the reference number from the DVD file, so that in the future it is easy to look up "Greek holiday 2009" under "G", find the reference number and go straight to your DVD of images. As a professional photographer with thousands of images, I have everything backed up on my hard drive and can quickly find an image. But in 10 years time, it will be quicker to use the reference book and DVD, rather than trawl through the many hard drives I will have amassed by then! If you are not a professional photographer, this DVD system is a very easy way of finding your images.

Stage 3 – Editing

Now you have all your images safely stored you can edit them. Most cameras come with a programme for editing your images; download this to your computer and follow the instructions given by your camera manufacturer.

A. Open the browser and your images will be displayed in a similar way to the image below.

B. Delete everything that you are unlikely to use!

C. Remove all shots that are blurred, but not "artistically blurred"!

D. Now go back through the shots and remove any that are very similar to others. Be ruthless! Too much choice is exhausting!

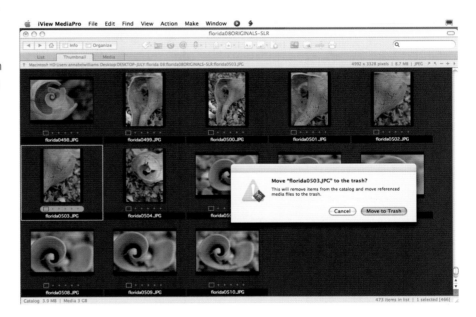

Stage 4 – Enhancing

Once you have chosen the images you want to keep you can play with them to your heart's content on Photoshop or other similar programs (see pages 24-27).

If you do not want to use Photoshop, or prefer something simpler to start with, there are many simple programs that provide you with a choice of ways to change your pictures at the press of a button. Basic programs like Picasa can be downloaded free from Google, and are a great way to store all your images and play with them very simply. This is the program I have on my home computer for my family to download their snapshots, and do whatever they like with them. I tend to use iPhoto on my Apple Mac for my own holiday snaps etc. and for my professional pictures I download as above and use Photoshop.

If you want to take up photography professionally, more sophisticated programs like Aperture (Apple) and Lightroom (Adobe) will store and enhance your images and can also link to Photoshop.

Printing and Presentation

There are many ways of printing your pictures; they can be printed onto paper, glass, wood, linen, canvas, acrylic, fabric; in fact probably anything you can think of! Many people print images onto cushions, blinds, wallpaper and even hand bags.

These three pictures have been placed together to create one large piece of art, which works well because the horizon lines in the pictures are all in the same place.

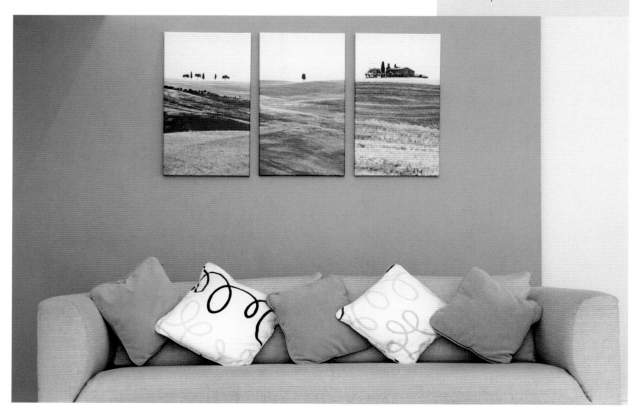

» Don't be afraid to go big! I often see beautiful pictures which are hidden away in rooms, as if the owner was afraid to show them.

Colour

I like to present my pictures in a very simple way; I find if there is too much fuss it takes over from the image itself. Images should create impact in a room, even if you are trying to blend the colours in with the décor.

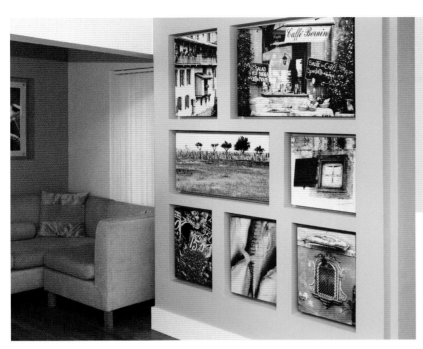

This wall was originally a fireplace, which has been covered with a framework of wood to create apertures in which to place the pictures. The images have been printed onto "chunky" canvas blocks and fitted specifically into the spaces to create a bright wall of art. This is a great way of using images shot on a compact camera, as you can create huge impact without worrying about losing quality by enlarging the images.

These images are framed in acrylic to match the table and chairs.

» Look for ideas in shop windows, house magazines, on the internet; you will find many ways of presenting a picture.

ANNABEL'S TIPS

Collections of Images

If you have taken your images on a compact camera and cannot enlarge them enough to fill your chosen space, try to create a large piece of art by putting several small images together.

This room is full of natural texture, and earthy tones, and needs an image to complement the many natural objects which the owner collects. The photograph is of a lake in a nearby wood, and has been bonded to a large piece of foamcore. To create more interest the image has been split into four parts.

Exhibiting Your Work

So now you've become an expert, perhaps you'd like to exhibit and sell your work! I often find that people get very excited about being able to create their own art – it's a great feeling to be allowed the freedom to be inspired, because you have stopped worrying about your camera, and are going out shooting everything you see.

I always choose plain white mounts around my pictures if they are being framed, as I feel that coloured mounts blend too much with the actual image and I prefer the image to stand out from the frame.

Many photographers I have taught suddenly find themselves filling their house with art and then they have no room left for all the new images they take.

The next natural step is to exhibit and try and sell your work. So how do you do that?

First of all – BELIEVE YOU CAN DO IT!

Most creative people would love to sell their work but are often held back by their lack of confidence. Just because you know it was easy to take, does not mean it is not good enough to sell. Show your pictures to your family and friends and watch their reaction. If people constantly say your work is good – then YOUR WORK IS GOOD! Other people will also like it and therefore it has a market.

ANNABEL'S TIPS
Looking After Your Prints

If you have your pictures professionally printed at a quality lab, the images should last many many years, provided you do not place them in direct sunlight. Strong sunlight will fade the image, no matter how hard you try to protect it.

However, if you are determined to put your picture in a conservatory, then at least you have all the digital files backed up so that you can replace it at a later date!

I have been known to create frames which are reversible, so that after a few years, if it fades, it can be turned round!

Images on foamcore need to be hung in a place where people won't brush past them, or furniture cannot touch them, as foamcore is very delicate and will damage very easily. It is a cheaper solution than canvas, but much more likely to get dented and scratched.

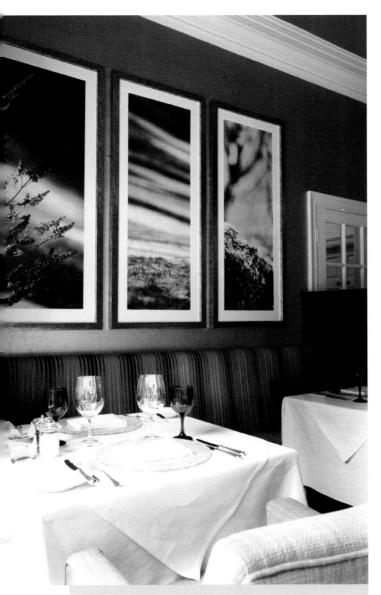

ANNABEL'S TIPS

Framing

Make sure you use a top quality framer to frame your images. Inserting a print into a standard frame will result in the print moving, and any light falling onto the picture will only enhance any faults with the lack of proper mounting. Prints need to be dry mounted or heat sealed down to board before being properly stuck to the mount, in order that the print stays in place and looks perfect.

Always sign your work – it will instantly look more like art! You can sign the mounts in pencil if you are framing the image, or have your signature scanned onto other materials such as canvas or acrylic.

TIP – Make sure you can read your signature – this way people will remember you. I have my cheque book signature, which is totally illegible, and my "art" signature – which can be read easily.

These images were shot for the walls of a hotel restaurant. We could have placed them as small prints in the middle of the wall, but decided to go for more impact by filling the space. Images behind glass, if they are well done, always look "expensive" to me, and I love the reflections of light in the glass. Many people use non-reflective glass to counteract this, but I actually think it makes the image look flatter, and I much prefer the reflections.

Selling Your Work

The next problem is always pricing. Don't undersell yourself. Work out all your costs, and add enough money to make a profit. Profit is a great motivation! Make a list of every single expense you incurred to create the art and produce the final product. You will also need to cost out the running expenses of your business, if you are to set up professionally. You will soon find you need to charge more than you thought.

But have the confidence to believe you are worth it, and your art is worth it. There is no point in giving away your pictures or selling them too cheaply – you will soon become despondent when the bills come in. If they don't sell, then you haven't done your marketing properly – make sure you are marketing your work in places that are visited by the people that can afford the prices you need to charge.

TIP 1 – CREATE A WEBSITE SELLING YOUR OWN ART

A. Think about how you will market your site and get people to look at it.

B. Make it easy for people to buy your pictures by showing clear images and setting up a simple "pay on line" system.

C. Make sure you work out your costs – your product will be quite expensive to produce, and to send out – don't under charge.

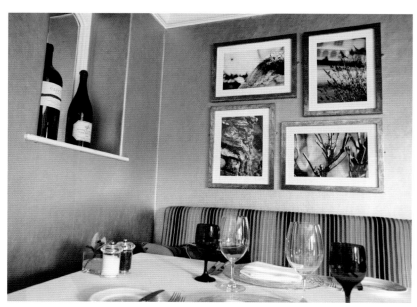

TIP 2 – EXHIBIT IN RESTAURANTS, SHOPS AND LOCAL BUSINESSES

A. Look for new businesses that are opening in your area and ask them if they have thought about their artwork yet.

B. Offer to exhibit your work on their walls for the cost of producing the pictures, or if they have no budget for art, consider producing it yourself depending on how many people you think will see the exhibition.

C. Print some high quality cards with an image on the front and your contact details, and place it where interested people will take your card. Make sure it is large enough to be seen, and use a bright attractive image.

D. If your artwork is to change every couple of months, use frames in which you can easily change the images, to avoid extra cost each time.

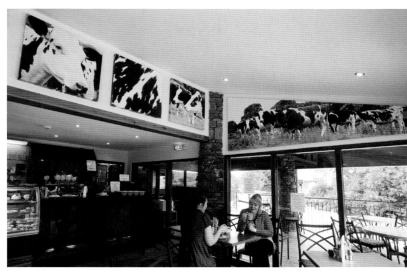

» Have the confidence that you are worth it and that your art is worth it.

TIP 3 – TAKE YOUR WORK TO GALLERIES

A. Make an appointment – don't just turn up, unless no one will see you!

B. Ask them if you could visit them for some advice, rather than tell them you want to sell pictures in their gallery – they will have lots of people saying this every day – you need to stand out and be different.

C. Take a few samples of your work rather than everything – less is more! If a few samples interest them, they will want to see more.

D. Present your samples well – some in a portfolio, and one or two in frames. Often a gallery owner will want to display the pictures in their own frames, and they may have their own opinion how a picture will sell best.

E. Listen to their advice – they are the expert.

F. Be open minded and prepared to change the way you do things if you think it will help your images to sell.

ACKNOWLEDGEMENTS

I would like to dedicate this book to Catherine Connor for giving me the time and freedom to be creative and indulge my passion for photography. I would like to thank her both personally, and on behalf of all the many photographers she trains, for giving us all the support and encouragement to develop and grow in our own different ways.

Her unique blend of positivity, enthusiasm and motivation is priceless.

I would also like to thank David Brockbank, Jane Breakell and my studio team for their constant support; my publisher Angie Patchell and designer Toby Matthews; Marko Nurminem for his expert photoshop work on all the images; Catherine Connor and Polly Williams for their 'behind the scenes' shots and my mother, Gil Murphy for passing on her artistic genes and allowing me to pick a huge selection of flowers from her garden, in order to shoot just one for pages 81 & 82!

Thank you also to all the amazing photographers who wrote to me after '99 Portrait Photo Ideas' with their incredible enthusiasm; I hope you are all as motivated by '99 Digital Photo Art Ideas', and I look forward to hearing your comments and hopefully seeing some of the art you are inspired to create.

Email studio@annabelwilliams.com to learn how to become a worldwide member of Aspire; the place to meet people like YOU!

A FINAL WORD …

I hope this book inspires you to go out and shoot your own art, and to be proud to hang it on your walls. As you may have discovered, I am very passionate about photography and also about inspiring people to see the easier side of what is often portrayed as so difficult and technical!

If you would like to experience a very different way of learning photography, or feel ready to embark on a career as a photographer, please go to www.annabelwilliams.com for details of our training courses and how to join our growing network of like minded people who all have one goal in common; to enjoy taking pictures and constantly be inspired and motivated!

Annabel Williams

To create your own art, go to **www.annabelwilliams.com/photoart** to upload your photos and create your own canvas blocks, acrylics and other art presentation.